PAST & PRESENT

HISTORIC ORLANDO

OPPOSITE: In the 19th century, Lake Eola was a sinkhole with an underground aquifer. (Courtesy Florida Memory, State Library and Archives of Florida, PR07987.)

PAST & PRESENT

HISTORIC ORLANDO

Elizabeth Randall
Photography by Bob Randall

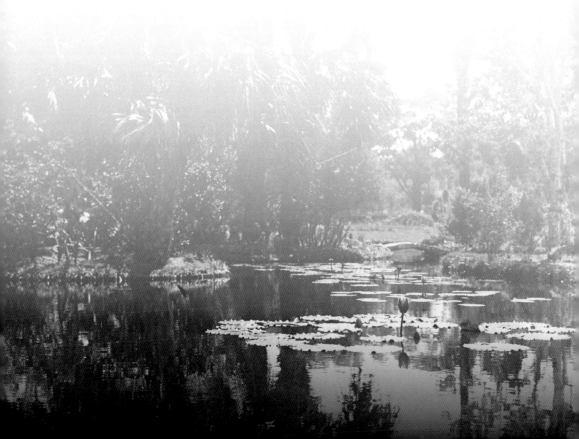

In memory of Eola J. Allen, niece of Orlando mayor J.H. Allen, and in loving memory of Veronica Drake, an independent woman from Chicago.

Library of Congress Control Number: 2022937204

Published by Arcadia Publishing
Charleston, South Carolina

Printed in the United States of America

For all general information, please contact Arcadia Publishing:
Telephone 843-853-2070
Fax 843-853-0044
E-mail sales@arcadiapublishing.com
For customer service and orders:
Toll-Free 1-888-313-2665

Visit us on the Internet at www.arcadiapublishing.com

ON THE FRONT COVER: Constructed in 1889, the Orlando Railroad Depot's Mission Revival architecture is attributed to designer H.H. Richardson. Once owned by the Atlantic Coastline Railroad Company, the depot and surrounding buildings were bought by entrepreneur Bob Snow in the 1970s and converted to nightclubs and restaurants. Today, the brick depot is listed in the National Register of Historic Places. The commuter SunRail tracks run beside the original station. (Courtesy of Florida Memory, State Library and Archives of Florida, PC2508.)

ON THE BACK COVER: Originally known as South Beach and Lake Sandy Beach, the Summerlin family, who donated the lake and park grounds to the city, renamed it Eola after a local woman and friend of Sam Summerlin. (Courtesy Florida Memory, State Library and Archives of Florida, PR07987.)

Contents

ACKNOWLEDGMENTS

This important book illustrating Orlando's evolution as a diverse and notable city would not exist without the gracious assistance and professionalism of the following librarians, research historians, educators, academics, archivists, assistants, and history lovers: Dixon Gutierrez, State Archives and Library of Florida; Katelyn Herring-Saltzberg, State Archives and Library of Florida; Melissa Procko, Orange County Regional History Center; Pamela Schwartz, Orange County Regional History Center & Historical Society of Central Florida; Todd L. Bothel, Jewish Museum of Florida-FIU; Heather Bonds, Historic Preservation Board, City of Orlando; Wenxian Zhang, Olin Library- Rollins College; Alyssa Windsor, Olin Library-Rollins College; David Benjamin and staff, Special Collections & University Archives Libraries, University of Central Florida; Tomaro Taylor, University of South Florida (USF) Libraries Special Collections; Kim Peters, Orlando Public Library; Tim Orwick, Orlando Memory; Stephen Herring, *Orlando Retro*; Walter Hawkins, Jones High School Historical Society; Katrece Pitts, Wells'Built Museum of African American History and Culture; David Matteson and David Bain, LGBTQ History Museum of Central Florida; HuntonBrady Architects; Karen Hart, Linda's LaCantina; Karick A. Price Jr., Price Collins Motors; Sandra Worden Pickett; Denise and Steven Allen; Ron Jaffe; and Grace A. Chewning, Orlando city clerk emeritus. I would like to express my heartfelt appreciation to all of the above individuals, and to the institutions, memories, and societies they represent.

Unless otherwise noted, all present images were photographed by Bob Randall.

INTRODUCTION

Architecturally, culturally, and industrially, Orlando grew from a rural community to a sleek city of highways and skyscrapers, housing hundreds of thousands. Its climate, economy, and public schools attract residents from all over the world, and Orlando benefits from these global influences. Old and new citizens of Orlando join the tapestry of the city's history, a history rooted in the Deep South as well as innovation and diversity.

Orlando, like most Florida cities, originated as a rail stop, a beautiful land full of orange groves, pine forests, pristine lakes, wildlife, and livestock. Settled in 1875, just 30 years after Florida became a state, Orlando was one of the last wild frontiers east of the Mississippi. From Indian trails to dirt paths, to brick roads, Orlando grew a web of access through ever-expanding highways, interstates, and turnpikes. Its central location was always an advantage as a jumping-off point.

Orlando's evolution entailed a series of economic trends, including cattle, citrus, military training, and, finally, its present dominance in hospitality and tourism, albeit with some expansion in high-tech and health-care industries. Like many cities experiencing rapid growth, Orlando is often described as a city lacking a history, but nothing could be further from the truth. While the value of Orlando's architecture and antiquity was often considered less important than urban growth, private and public agencies have slowed the tearing down and building up. The destruction of the San Juan Hotel in 1980 appears to have been the impetus for the Orlando Historic Preservation board to create the first historic district in downtown Orlando. At present, Orlando has six overlay historic districts of buildings, sites, and structures intended for preservation. Many of these are also listed in the National Register of Historic Places.

Orlando represents diverse architectural styles of the last 150 years, as well as diverse cultures. This book aims to unite all historic districts and the people therein, recognized throughout the city by buildings, landmarks, and most of all, by memories. What compelled our Orlando ancestors to photograph certain memories and not others? These "past" memories exist today because of archival record-keeping, and this book culled the best of what's available. Since many of the sites listed in this book were moved or ceased to exist, unless otherwise noted, the historic designation refers to the original address and capacity of the structure or area.

RECREATION AND ARTS

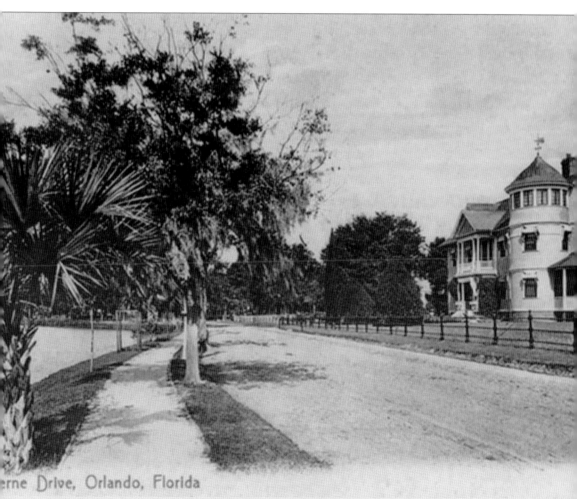

erne Drive, Orlando, Florida

North Lucerne Circle was a dirt road bordering Lake Cherokee and the Dr. Phillips house in the early 20th century. It provided a place for a scenic stroll for residents then, as it does today. (Courtesy of Florida Memory, State Library and Archives of Florida, pc2564.)

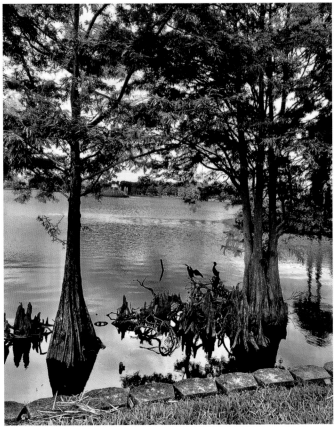

In the 19th century, Lake Eola was a sinkhole with an underground aquifer. Originally known as South Beach and Lake Sandy Beach, the Summerlin family, who donated the lake and park grounds to the city, renamed it Eola after a local woman and friend of Sam Summerlin. As Orlando's first public park, Lake Eola is still a hub of outdoor Orlando as well as a sanctuary for geese, ducks, and nesting swans. (Past image, courtesy Florida Memory, State Library and Archives of Florida, PR07987.)

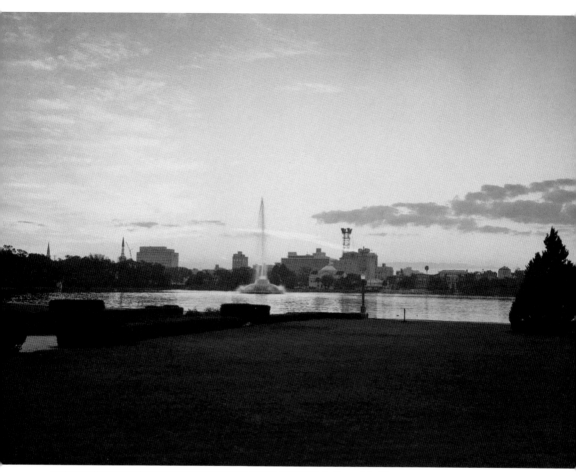

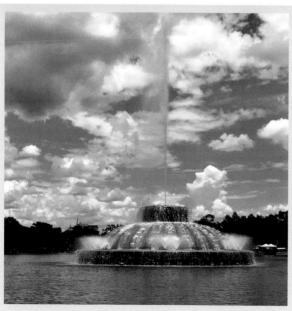

The domed fountain, installed in 1912, was replaced in 1957 with the Centennial Fountain. It was restored and renamed again as the Linton E. Allen Memorial Fountain in honor of the banker who undertook the civic project. The fountain recycles 6,400 gallons of water a second, shooting sprays 100 feet in the air. Illuminated at night with colored lights, its iconic image is featured on Orlando's flag. (Past image, photograph by Tim Orwick, courtesy of Orlando Memory.)

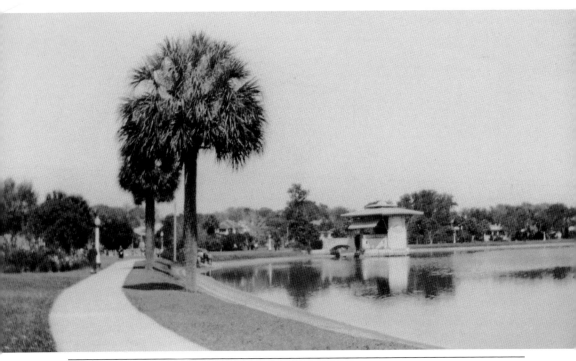

Built in 1886 on the south side of Lake Eola Park, the original bandstand was torn down and rebuilt on the west side of the circular path surrounding the lake. In 1924, Ida Ryan and Isabel Roberts designed a new bandstand, pictured here. Later there was another band shell, the Walt Disney Amphitheater. Banked by flowers and a view of the Orlando skyline, the venue hosts concerts and plays. It has been painted in rainbow colors in honor of those who lost their lives in the 2016 Pulse nightclub shooting. (Past image, photograph by Harold S. Ritchie, courtesy of Florida Memory, State Library and Archives of Florida, PR 20684A.)

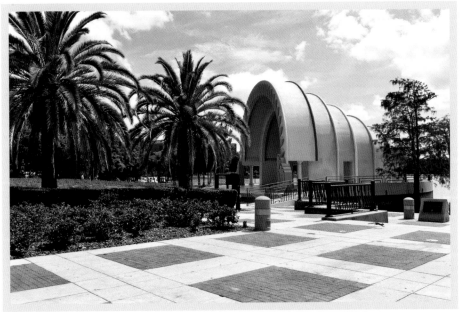

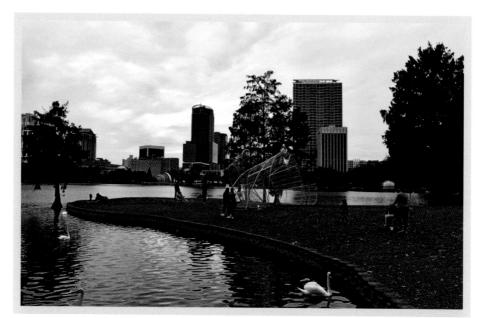

The land for Lake Eola Park was donated by Jacob Summerlin, a city founder. In the past, people rowed and fished from the peninsular vantage point of the park, which is still a spot where residents and tourists enjoy photographing the city skyline, pedaling swan-shaped paddle boats, hiking on the circular sidewalk, and enjoying performances at the Walt Disney Amphitheater. (Past image, photograph by Sandra Hinson, courtesy of the Department of College Archives and Special Collections, Olin Library, Rollins College, Winter Park, Florida.)

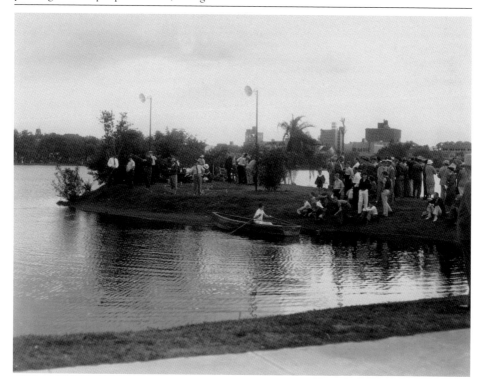

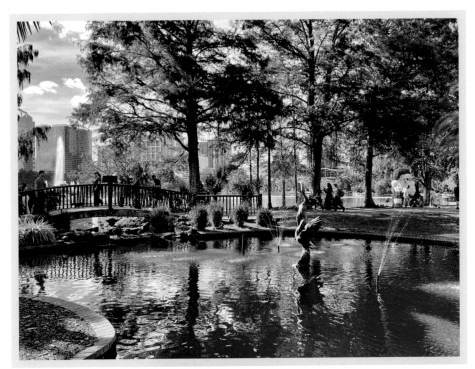

In 1964, this view from Lake Eola featured the Orlando skyline. Today, the *Fantasy Swan* sculpture by S. Hardthalae of Thailand is one of many artworks dominating the landscape of the park. Donated by Walking Works of Art, it is based on the legend of a princess who sought the identity of her soul. After traveling through time, she and her pet swan landed upon a tranquil crystal pond. (Past image, photograph by Hackett, courtesy of Florida Memory, State Library and Archives of Florida, C640361.)

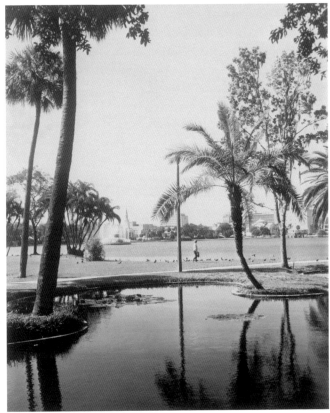

RECREATION AND ARTS

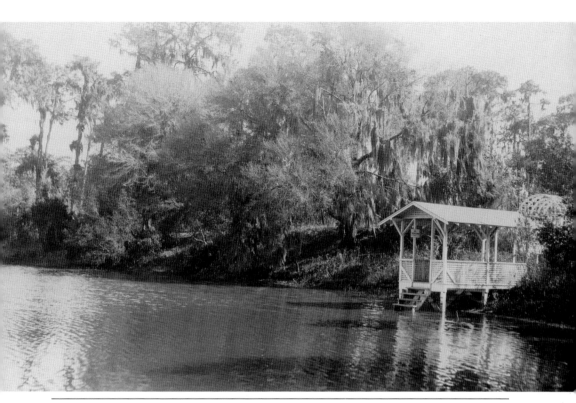

In 1915, this dock and gazebo on Lake Highland was an oasis in the wilderness. Today, Lake Highland Park borders a residential refuge on the north side of Lake Highland across from the Orlando Urban Trail. It features historic homes, a view of downtown Orlando, towering oak trees, and open grassy space for people and pets. (Past image, photograph by Seymour S. Squires, courtesy of Florida Memory, State Library and Archives of Florida, PR20683.)

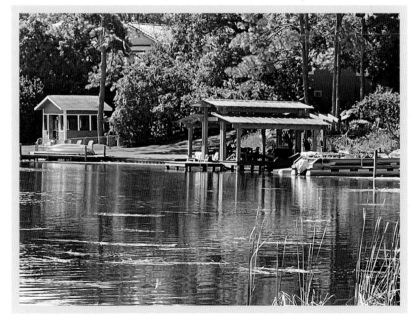

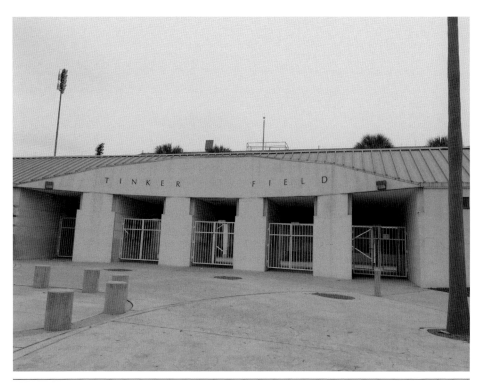

In 1914, Tinker Field, named after baseball Hall of Famer Joe Tinker, was comparable to Wrigley Field, hosting major league greats such as Jackie Robinson, Hank Aaron, Joe DiMaggio, Lou Gehrig, Mickey Mantle, and Babe Ruth. In 1964, Martin Luther King Jr. gave a speech from the pitcher's mound. Today an outdoor entertainment venue, the Tinker Field History Plaza is listed in the National Register of Historic Places. (Past image, courtesy of Stephen Herring, *Orlando Retro*.)

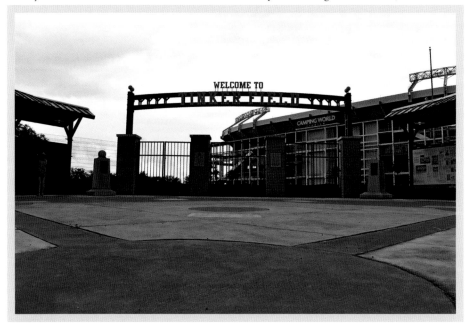

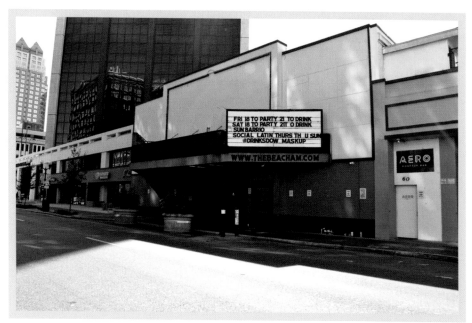

Constructed near the site of the Old County Jail, the Beacham Theater was built in 1920 and connected to the San Juan Hotel by an underground tunnel, which enabled entertainers to escape fans. The design was Art Deco, Exotic Revival, and Mediterranean Revival. Originally, the venue featured vaudeville shows and movies. Today, the Beacham is a nightclub with a modernized marque on its original façade. (Past image, courtesy of Florida Memory, State Library and Archives of Florida, RC05892.)

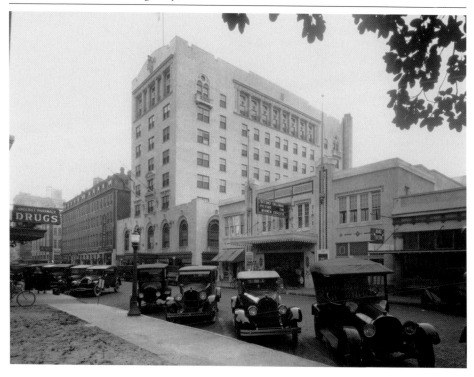

The South Street Casino was more a nightclub than a gambling venue. It provided a dance floor for African Americans in the Parramore district of Orlando and headlined entertainers such as Cab Callaway, Ella Fitzgerald, and Ray Charles. Built by Dr. William Monroe Wells and located next to the Wells' Built Hotel, the casino was eventually replaced by the physician's Wells Heritage House, an Orlando historic city landmark. (Past image, courtesy of the Wells' Built Museum of African American History and Culture.)

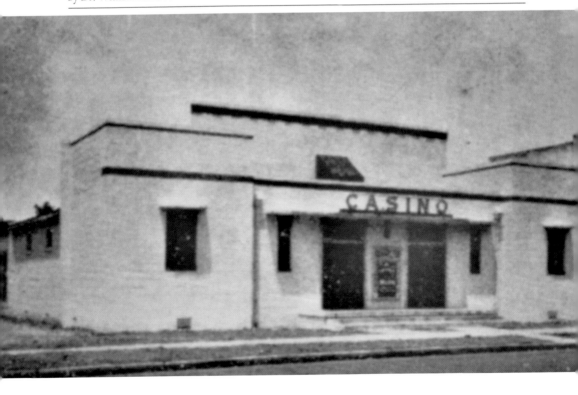

RECREATION AND ARTS

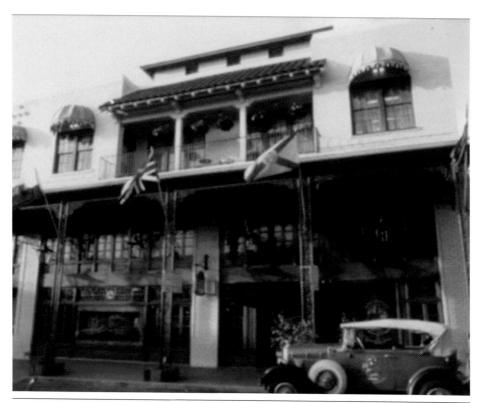

Originally a department store, this lot on West Church Street transformed in 1974 into Rosie O'Grady's Good Time Jazz Emporium. Revitalizing downtown Orlando, it featured signature drinks, a Dixieland band, and singer "Red Hot Mama" Terry Lamond accompanied by can-can girls dancing on the bar. The ceiling, the mezzanine, and a second-floor tile canopy date from the 1920s. Today, the site is a chain restaurant. (Past image, courtesy of Florida Memory, State Library and Archives of Florida, K022062.)

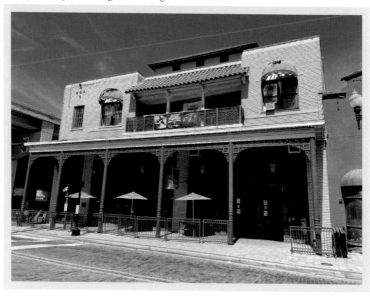

Built in the 1930s, the Parliament House became a lodge, and then an internationally famous gay resort. Headlining LGBTQ entertainers performed regularly there. In 2020, it was sold at foreclosure and razed. The vacant City Arts property is expected to be the new downtown Parliament House. The City of Orlando acquired the Parliament House's multicolored Art Deco sign, which is now part of Orlando's cultural history. (Past image, courtesy of the LGBTQ Museum of Central Florida.)

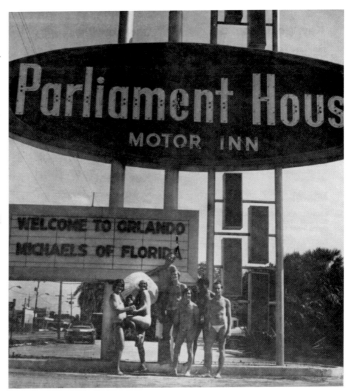

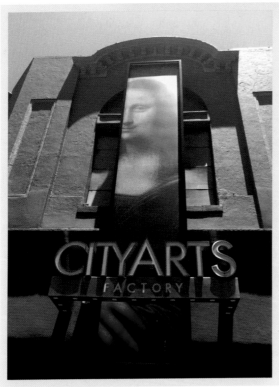

RECREATION AND ARTS

In the 19th century, the Rogers Kiene Building was known as the Old English Club, frequented by Englishmen who came south to raise cattle and grow oranges. Home to the Downtown Art District, the 133-year-old two-story Queen Anne–style building features an asymmetrical roof, gables, a tower, and a spired turret. The metal siding was imported from Europe. Today, it is an art gallery listed in the National Register of Historic Places. (Past image, courtesy of the Orange County Regional History Center, 2011-037-0032z.)

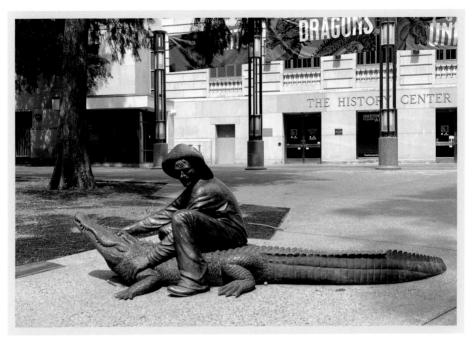

The photograph of a yokel from the mid-1880s wrestling a gator in the middle of dusty Orange Avenue is an iconic Orlando image. Today, "Live Alligator and Cracker Team" is immortalized in Orlando's Heritage Square Park as a bronze statue sculpted by Scott Shaffer. This time, the alligator tormenter is flanked by alligators sculpted by Craig T. Ustler. (Past image, photograph by Stanley J. Morrow, courtesy of Florida Memory, State Library and Archives of Florida, RC06271.)

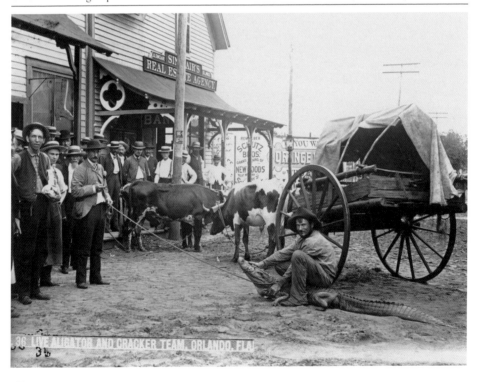

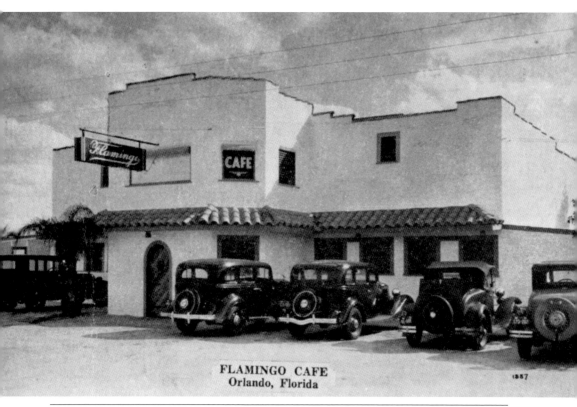

FLAMINGO CAFE
Orlando, Florida

Built outside Orlando city limits during Prohibition, the Flamingo Café was a restaurant, casino, and entertainment venue popular with its tuxedo and evening gown–clad clientele. Proprietor Sam Warren provided bootleg liquor, gambling in the back room, a top chef, and a dance floor where entertainers sang. Today, the site houses a family restaurant, and all traces of the Roaring Twenties club are gone. (Past image, courtesy of Florida Memory, State Library and Archives of Florida, n036319.)

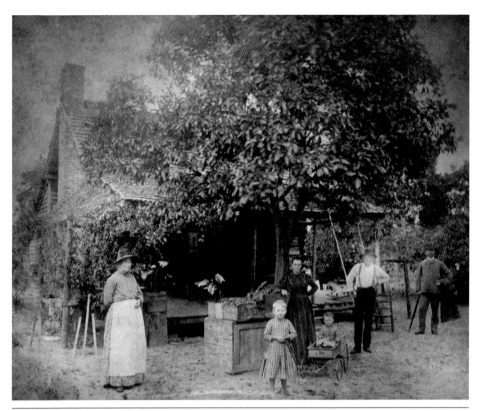

The 19th-century Mizell house in Leu Gardens was first owned by Angeline (pictured here on the far left) and David Mizell, a sheriff killed in the line of duty. In 1936, Harry P. Leu purchased the property, planting exotic seeds and plants from his worldwide travels. Leu donated the 50 acres of flowers, foliage, and wildlife to the City of Orlando in 1961. The Mizell house is now a museum. (Past image, courtesy of the Orange County Regional History Center, 1961-009-0001.)

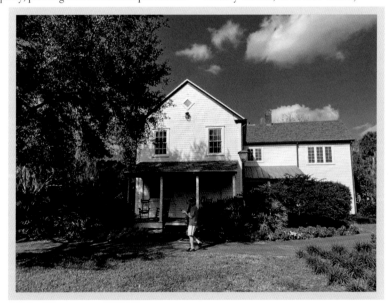

FAITH

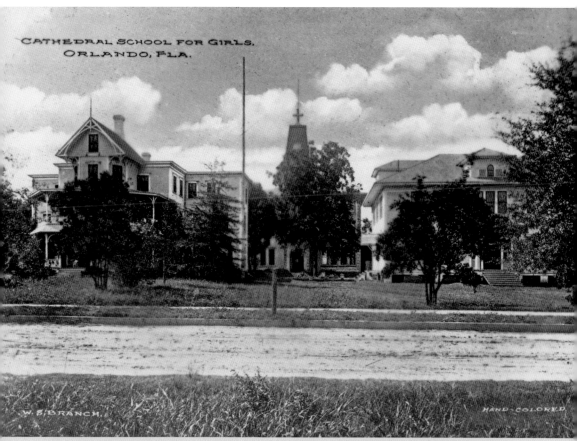

The Cathedral School for Girls was a private school located near Lake Eola in the early 20th century. (Courtesy of Florida Memory, State Library and Archives of Florida, pr07972.)

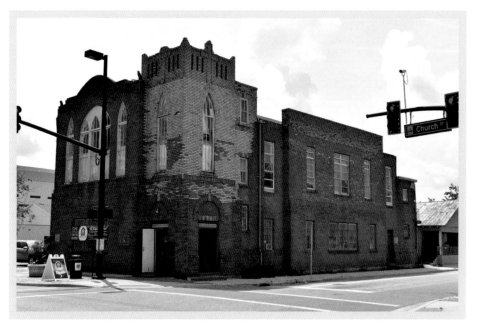

Ebenezer United Methodist Church, a brick Gothic and Romanesque Revival–style building, dates to the 1930s as the first African American Methodist church in Orlando. The brick color varies because of the decades-long span of its construction. Now the Greater Refuge Memorial Church, it is included in the state's Florida Black Heritage Trail, and is a historic Orlando landmark. (Past image, courtesy of the Wells'Built Museum of African American History and Culture.)

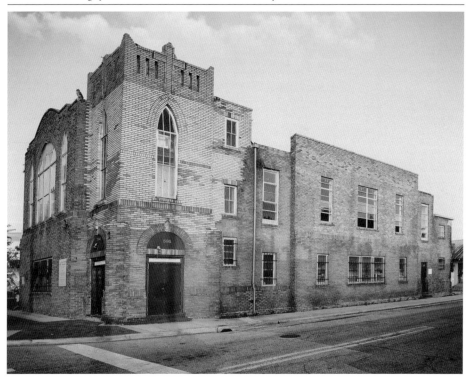

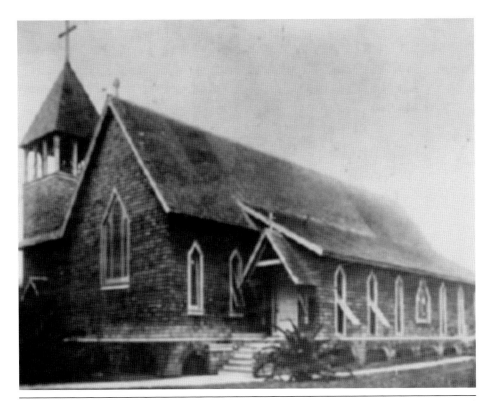

Francis Eppes, grandson of Thomas Jefferson, held the first Episcopal services in his home in Orlando. This grew into the St. Luke's Mission Church in 1884 and became the Cathedral Church of St. Luke, where Eppes is buried. The Gothic Revival architecture was planned by Philip Frohman, and it became the seat of the Diocese of Central Florida and a participant in the City of Orlando Historic Plaque Program. (Past image, courtesy of Florida Memory, State Library and Archives of Florida, PC15661.)

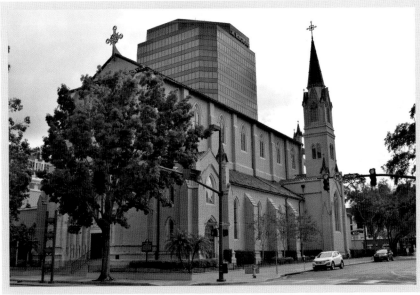

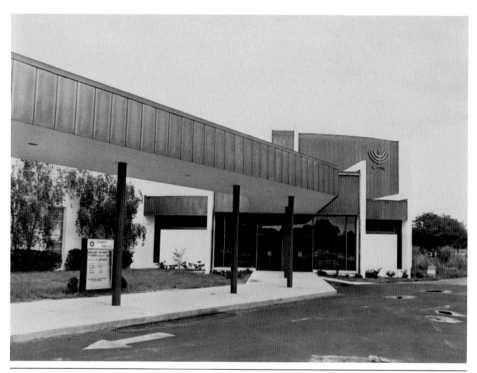

Temple Israel, built in 1963, accommodated a growing population of worshippers after a local family donated land for the Eli Street synagogue. The modern design with large glass panels accommodated 350 congregants and featured windows made of tiles of inch-thick glass to enhance the refraction of light. Temple Israel moved to Winter Springs, and today this building is home to St. Paul's Presbyterian Church. (Past image, courtesy of Florida Memory, State Library and Archives of Florida, MS25650.)

BUSINESSES

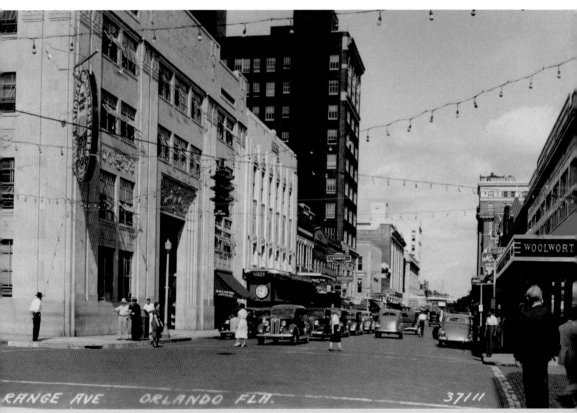

Pictured here are the First National Bank and Trust and the Kress Store on South Orange Avenue, where many downtown Orlando businesses flourished prior to and after the Great Depression. The Woolworth store is across the street. (Courtesy of the Orange County Regional History Center, 2013-037-0004.)

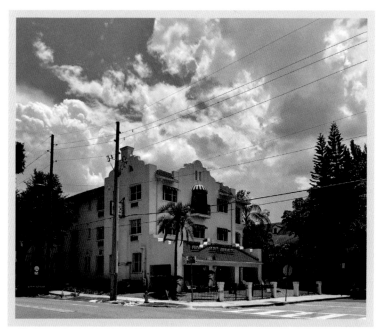

Built in 1922 by Edward Salmon, the Bonnie Villa Hotel, a Spanish-style three-story property, consisted of 40 rooms. Over time, it was home to the Young Men's Christian Association, a hospital, a retirement home, a youth hostel, and a Panera Bread restaurant. Now a boutique hotel and brewing company with a modern interior, the building is part of the Lake Eola Heights Historic District, overlooking Lake Eola Park. (Past image, courtesy of Denise Allen.)

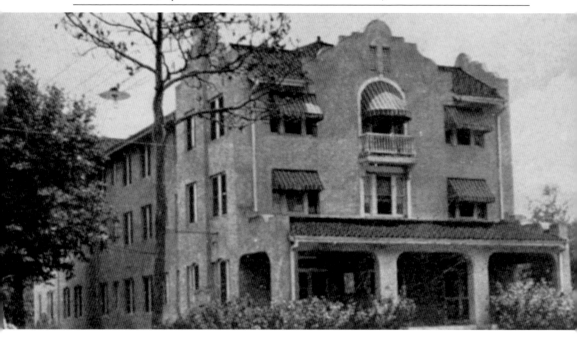

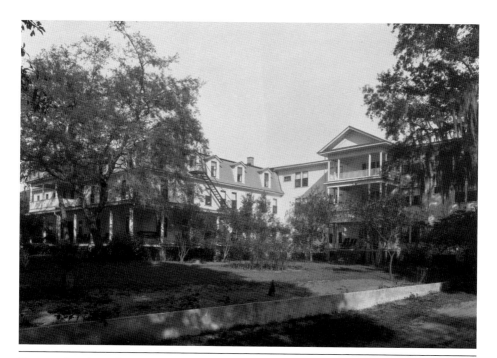

Renovated in the early 20th century by Robert Rowland, (whose descendants still reside in Orlando) the Colonial-style Lucerne Hotel became a winter resort popular with retirees. Known as "the New Lucerne" after the first one burned down in 1886, the hotel featured nine porches and an abundance of azaleas. Razed in the 1960s, today the location most closely approximates the Dr. Phillips Center for the Performing Arts. (Past image, courtesy of Florida Memory, State Library and Archives of Florida, PR08004.)

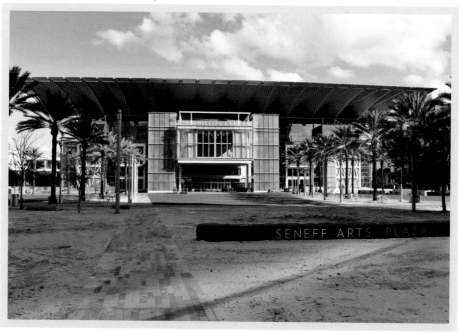

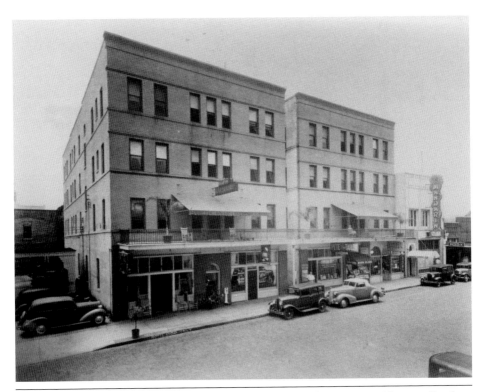

The brick Commercial-style Empire Hotel, built in 1913 by James MacGruder, competed with the grand San Juan and Angebilt Hotels. To attract guests, it lowered room prices and offered amenities such as air conditioning and hot and cold running water in each of its 100 rooms. The ground level was occupied by a succession of businesses, and today is a bar. (Past image, courtesy of Florida Memory, State Library and Archives of Florida, FR0749.)

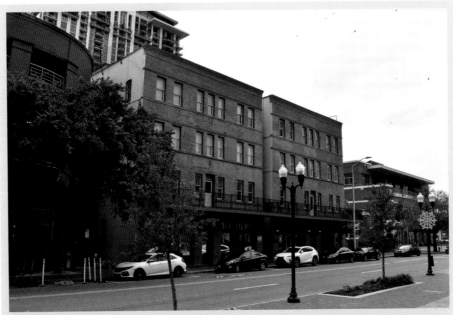

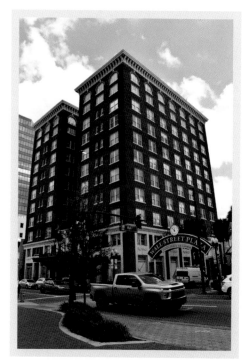

The Italian Renaissance Revival–style 250-room, 11-story Angebilt Hotel, designed by architect Murry S. King, competed with the eight-story San Juan Hotel on Orange Avenue. Henry Ford, Thomas Edison, and Joan Crawford stayed at the hotel in the Roaring Twenties, but in the ensuing years, "the Jewel of Downtown Orlando" suffered bankruptcy, the Great Depression, and fire. Today, the Angebilt houses a bar and offices on the ground floor. (Past image, courtesy of Florida Memory, State Library and Archives of Florida, PR08014.)

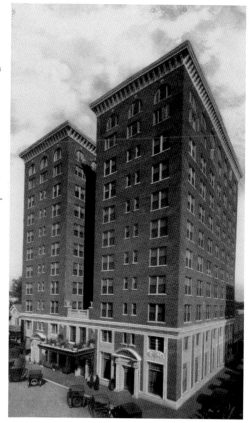

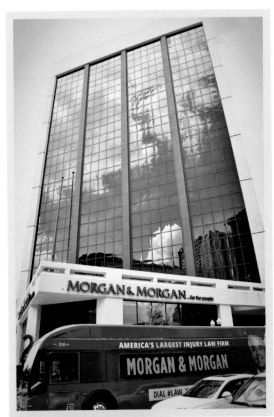

In 1885, the San Juan Hotel, owned by Harry Beeman, was the premier Orlando location, providing amenities and a view of the jail from the second floor. Demolished in 1980, it prompted the creation of the Downtown Historic District by the Historic Preservation Board of Orlando. Pieces of the hotel's terra-cotta ornaments are housed today in the Orange County Regional History Center. Today, the closest skyscraper to the old hotel is a law firm. (Past image, courtesy of Florida Memory, State Library and Archives of Florida, RC14103.)

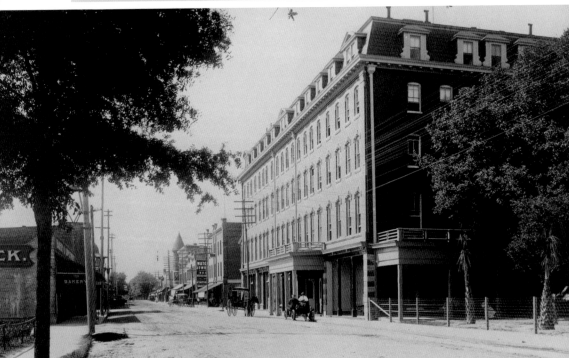

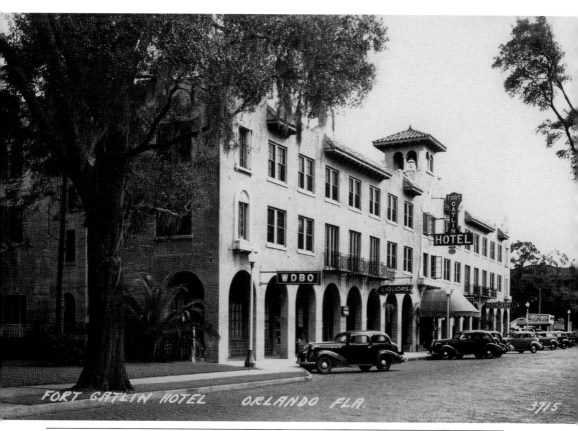

Named after Fort Gatlin from the Seminole Indian Wars, the Fort Gatlin Hotel opened in 1926 on North Orange Avenue in Orlando. The hotel had 150 rooms, a radio station, and hand-painted murals in the dining room. The Spanish Colonial–style building was sold to the *Orlando Daily News* in the 1950s and was demolished to make way for the *Orlando Sentinel Star*. Today, it is an empty building of interest to prospective hoteliers. (Past image, courtesy of the Orange County Regional History Center, 2013-024-0015.)

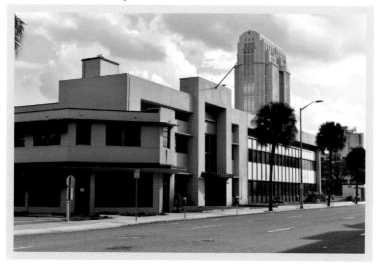

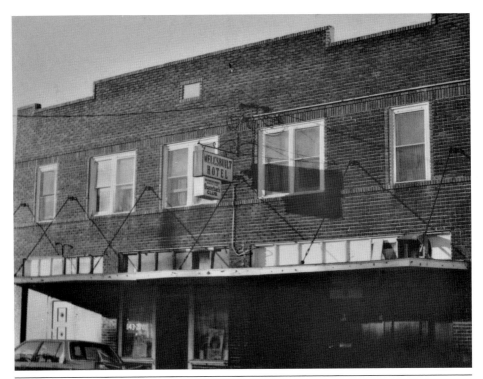

Jim Crow laws banned African Americans from the Angebilt Hotel, so they stayed at the Wells' Built Hotel. The famous *Green Book* guide listed the hotel as one of the havens of the South, assisting African Americans in locating safe lodging. Restored by the Association to Preserve African American Society, History and Tradition, today Dr. Wells's hotel is a museum listed in the National Register of Historic Places. (Past image, courtesy of the Wells' Built Museum of African American History and Culture.)

In the 19th century, the 51 rooms of the Tremont Hotel were the afterlife of older buildings, comprised of parts of a church, a county office, and a hotel. Owned by a sea captain who used the hotel to finance his travels, it was demolished in the 20th century. Today, the site is occupied by a downtown skyscraper that once housed a bank and now leases offices. (Past image, courtesy of Florida Memory, State Library and Archives of Florida, n036348.)

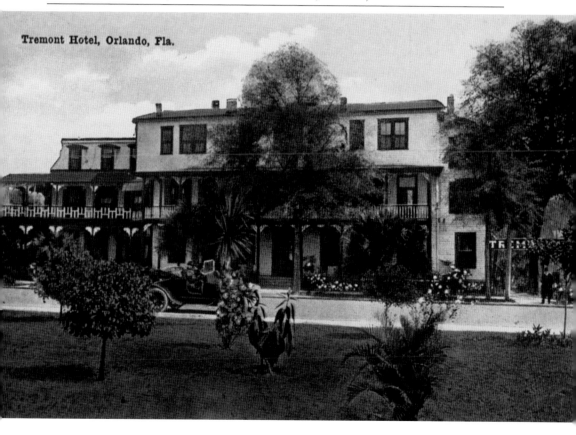

Tremont Hotel, Orlando, Fla.

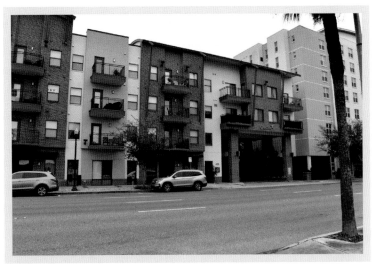

The 275-room Orange Court Motor Lodge on North Orange Avenue was designed in the Spanish Revival style by G. Lloyd Preacher in 1924. The hotel included a Spanish garden, an orange grove, and a heated swimming pool. Demolished in 1990, the present-day Camden Orange Court Apartments occupies the same site as the former lodge in the north quarter of downtown Orlando. (Past image, photograph by Richard Spencer, courtesy of Special Collections & University Archives Department, University of Central Florida Libraries.)

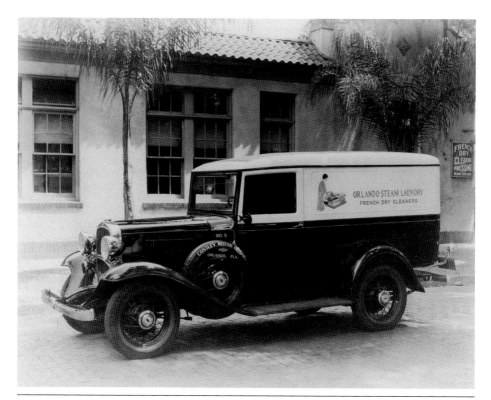

The Orlando Steam Laundry Company, a pickup and delivery service, was one of the first dry cleaners in Central Florida. Sold to I.N. Burman in 1929, it maintained Jewish ownership until its dissolution in the 1970s. Multiple addresses are documented for the business, but the 1929 Orlando City Directory lists addresses on Concord Street and East Church Street near the present-day fountains. (Past image, courtesy of the Orange County Regional History Center, 2008-040-0005.)

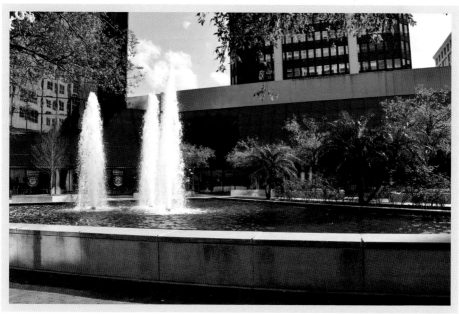

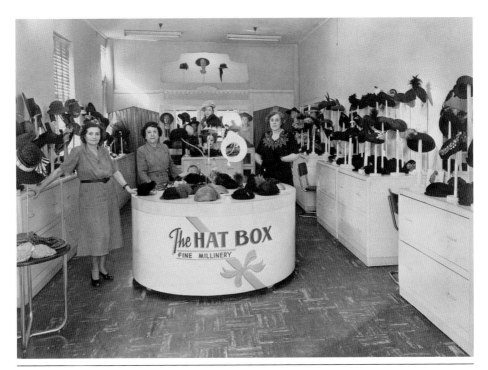

Located in the stucco Spanish Colonial–style Dolive Building on North Orange Avenue, the Hat Box was a millinery shop owned by Esther and Hyman Lieberman. Hyman ran the hat trade while Esther trimmed the hats in ribbons, bows, feathers, and fur. Known for charitable contributions to the community, some Lieberman descendants still live in Orlando. Today, the Hat Box is a bar, and the Dolive building has been saved twice from demolition by the Orlando Historic Preservation Board. (Past image, courtesy of Collections of the Jewish Museum of Florida, Florida International University.)

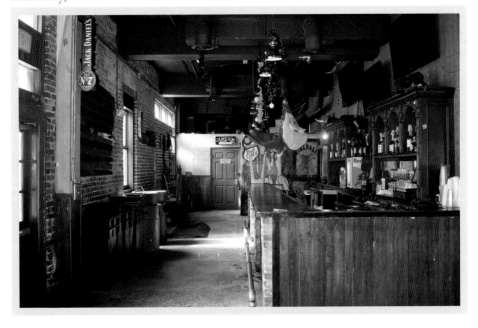

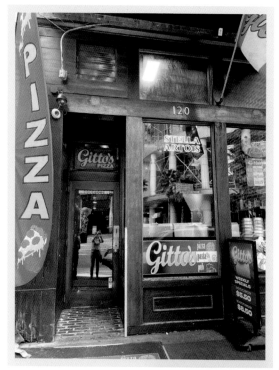

Leonard Fox opened the narrow two-story Leonards Mens Shop on Orange Avenue in 1940. A native of Britain, he dabbled in real estate before settling on haberdashery, also working for a time for David Hillman, who owned a dry goods store as well as the Orlando Steam Laundry Company. Leonards Mens Shop was Fox's third menswear store. Today, the site is a pizza restaurant. (Past image, courtesy of Collections of the Jewish Museum of Florida, Florida International University.)

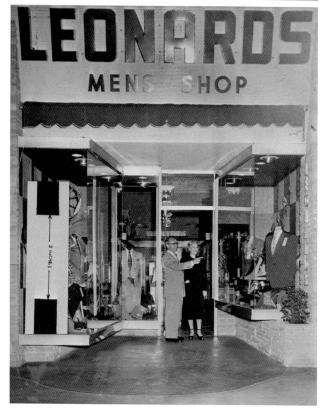

The Rose Building on Orange Avenue was designed by Murray S. King for future state senator Walter Rose in 1924. Rose planned to build a skyscraper but the Depression of the 1930s ensured the upper floors were never completed. Rose liked to brand his projects with his name, as seen here. Today, the ground floor is a sports bar. (Past image, photograph by Richard Spencer, courtesy of Special Collections & University Archives Department, University of Central Florida Libraries.)

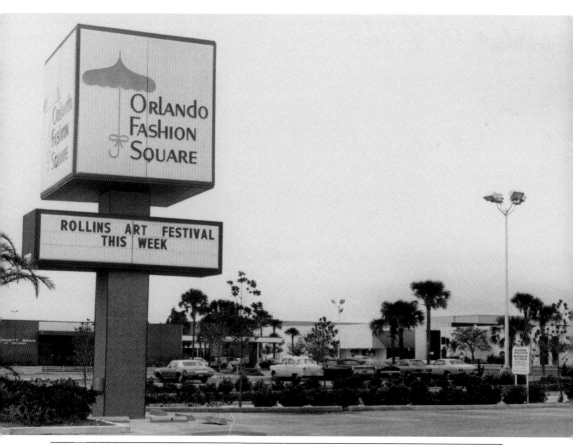

Orlando Fashion Square on East Colonial Drive started as a Sears store in 1963. Eventually, it grew into a Modern-style mall of one million square feet with four anchor stores. Many downtown businesses relocated to the mall. Eventually, a glut of Central Florida malls reduced Fashion Square to bankruptcy by the 21st century. Orlando City Council plans to turn Fashion Square into a complex with apartments, shops, and a hotel. (Past image, courtesy of the Department of College Archives and Special Collections Olin Library, Rollins College, Winter Park, Florida.)

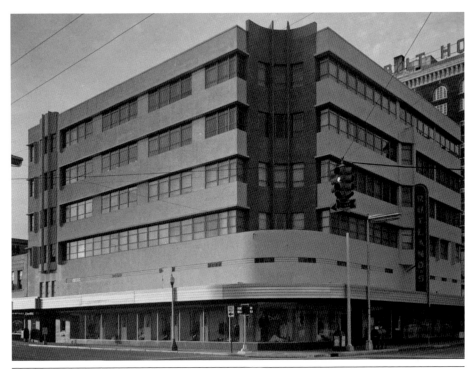

Local architect F. Earl Deloe designed this two-story Art Moderne structure for Joseph Rutland's menswear store around 1941. Three additional stories were added in 1952. In the late 1960s, Rutland's closed its downtown location but remained open in the suburban Colonial Plaza Shopping Center. Today, the building is a technology management business and a stop on the downtown Orlando historic district walking tour. (Past image, photograph by Tim Orwick, courtesy of Orlando Memory.)

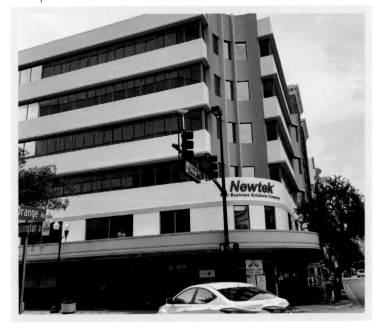

In 1942, J.B. McCrory's on South Orange Avenue was the five-and-ten chain's largest outlet and headquarters for the South. McCrory's closed in 1989, and its Art Moderne–style structure was demolished in 2003 along with the nearby Woolworth. Replaced with a high rise, it signaled the downtown effort to attract upscale businesses. Today, the ground floor is a cigar company. (Past image, courtesy of the Orange County Regional History Center, 2015-046-0004.)

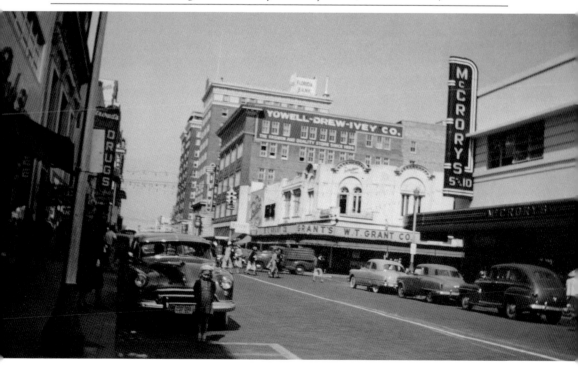

Built in 1963, Johnson Electric on South Magnolia Avenue was the go-to place for light fixtures and lamps in Central Florida. The classic Art Deco sign features geometric linear shapes as well as the classic sunburst motif. The building was torn down to create a parking lot, and the whereabouts of the Johnson Electric sign are unknown. (Past image, photograph by Tim Orwick, courtesy of Orlando Memory.)

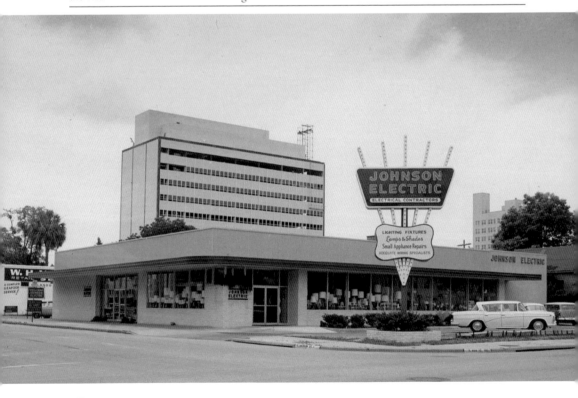

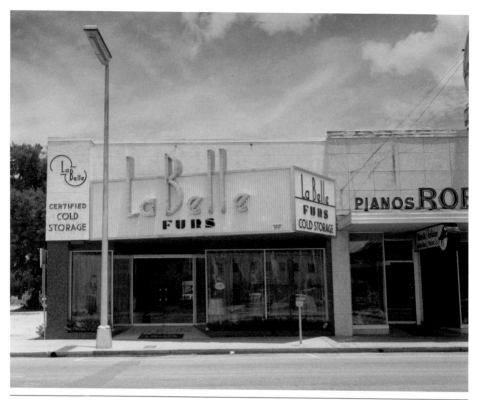

Sarah LaBellman, the first proprietor of La Belle Furs, fled persecution in Ukraine in 1919 and worked as a seamstress to support seven children in America. In the 1950s, she opened this store on North Orange Avenue, adding cold storage for furs. The neon La Belle sign is an iconic beacon in Orlando history as modern art and as the largest full-service furrier in Florida. Santa LaBellman, Sarah's great-granddaughter, continues the 100-year-old business. (Past image, photograph by Tim Orwick, courtesy of Orlando Memory.)

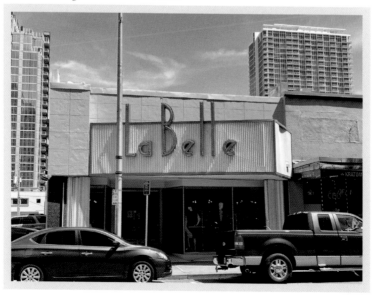

Joseph Bumby, a British immigrant, opened a store on West Church Street in the late 19th century selling farming goods. The building expanded and the Joseph Bumby Hardware Company was a family business until the 1960s. Then, the brick Victorian commercial-style building was sold to entrepreneur Bob Snow. Today, it is a hamburger joint with a liquor license, and is a City of Orlando historic landmark. (Past image, courtesy of Florida Memory, State Library and Archives of Florida K022057.)

Cubs shortstop and manager of the 1920s Orlando Tigers team Joe Tinker built this brick real estate building in 1925, planting multi-hued tiles around the Tinker name. The 20th-century commercial-style structure, accented in terra-cotta and glazed tile, is listed in the National Register of Historic Places. Today, the Tinker building houses the alternative newspaper *Orlando Weekly*. (Past image, photograph by John Markham IV, courtesy of the Orange County Regional History Center, 1996-054-0039.)

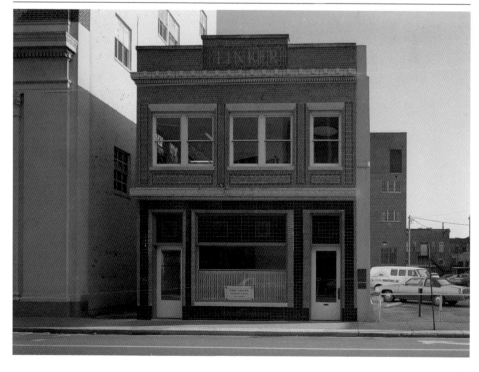

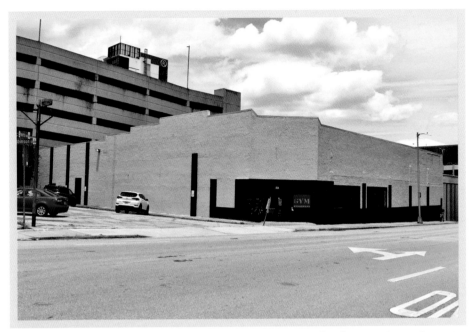

The George Stuart office supply store opened in 1938 on East Robinson Street and operated in the same location for 51 years. The stock was extensive and easily available long before online shopping. The store's slogan, "Check with George Stuart," was a local mantra. Today, the iconic George Stuart sign is gone, and the concrete block and stucco building is now a branch of a downtown gym. (Past image, photograph by Tim Orwick, courtesy of Orlando Memory.)

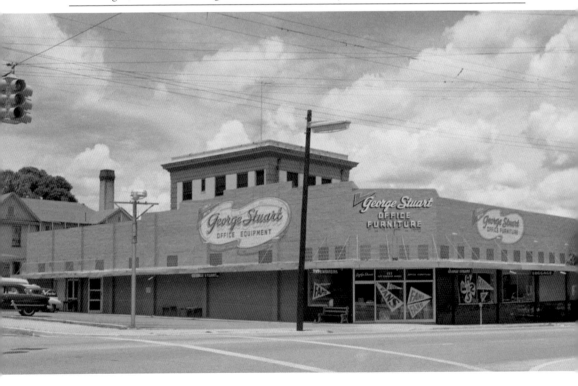

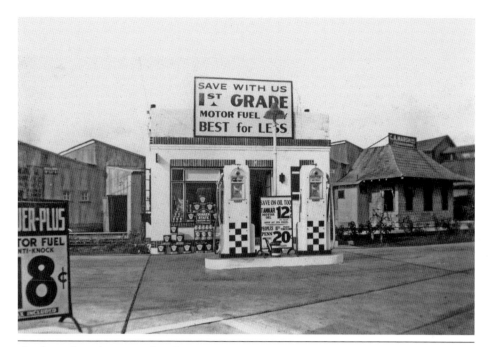

Florida Peoples Oil Company, based in New York, maintained a service and filling station on West Robinson Street in the 1940s, when gas was 18¢ a gallon. The filling station was built as a triangle to fit the lot. As Robinson Street was widened, the gas station disappeared. Remnants of parking spaces are still visible. (Past image, courtesy of Florida Memory, State Library and Archives of Florida, PR76184.)

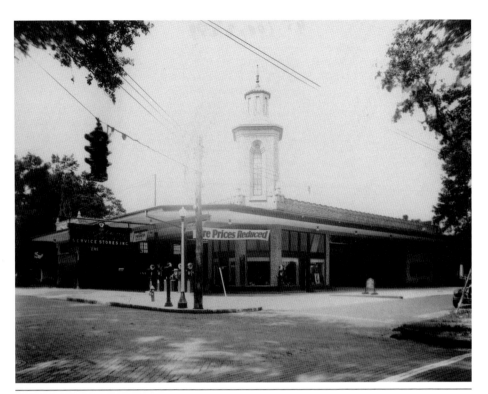

An official historic Orlando landmark since the 1980s, the brick Firestone building on North Orange Avenue was built by Harvey Firestone in 1929 at the start of the Great Depression. Designed by Florida architectural firm Francis J. Kennard & Son, the Art Deco– and Mediterranean Revival–style tire store and service station business survived for 60 years. Today, it is a concert venue. (Past image, courtesy of the Orange County Regional History Center, 1995-100-2574.)

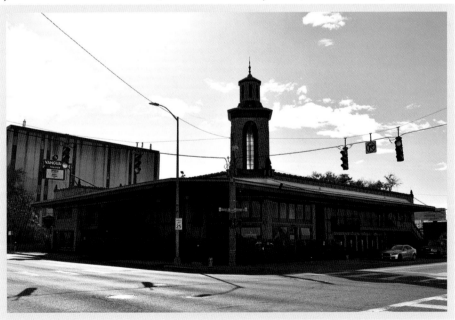

Price Collins Motors Inc. sold Studebakers on West Central Avenue in the 1950s. Although the Studebaker Corporation dated to the 1850s and the horse-drawn wagon, the Great Depression forced the automaker into receivership. Eventually, it merged with the Packard corporation, but it was out of business by the 1960s when compact gas-saving cars became popular. Today, the site of the former dealership consists of pylons to support Interstate 4. (Past image, photograph by Karick A. Price Jr.)

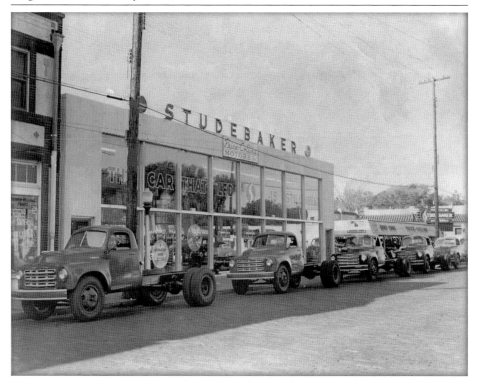

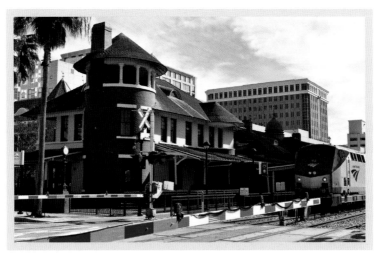

Constructed in 1889, the Orlando Railroad Depot's Mission Revival architecture is attributed to designer H.H. Richardson. Once owned by the Atlantic Coastline Railroad Company, the depot and surrounding buildings were bought by entrepreneur Bob Snow in the 1970s and converted to nightclubs and restaurants. Today, the brick depot is listed in the National Register of Historic Places. The commuter SunRail train runs beside the station. (Past image, courtesy of Florida Memory, State Library and Archives of Florida, PC2508.)

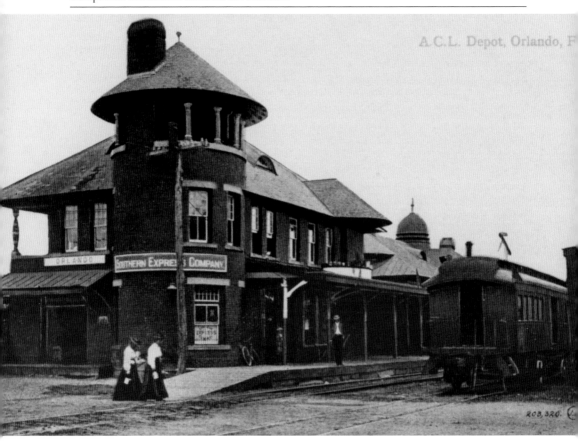

In 1886, the South Florida Foundry and Machine Company on West Kaley Street in the Parramore district made metal castings and parts for large machinery. Categorized in the Florida State Library under "African American men," it is likely the foundry was managed by and employed members of the African American community. A foundry and machine business in the same location has been active since the 1930s. (Past image, courtesy of the Department of College Archives and Special Collections Olin Library, Rollins College.)

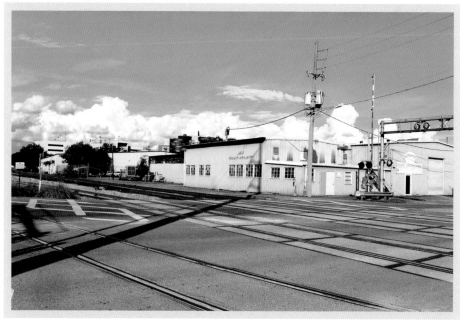

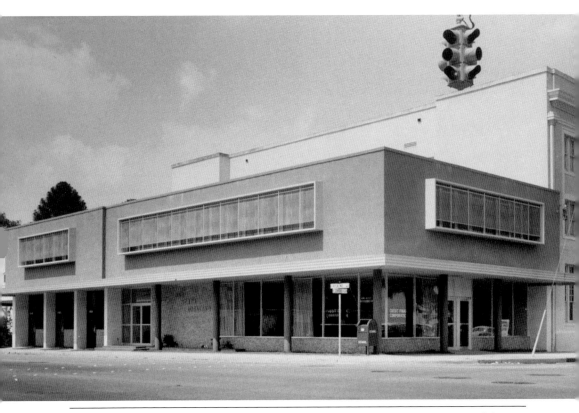

Built in 1958, the empty, low-rise, concrete block building at the northeast corner of Rosalind Avenue and Central Boulevard housed many businesses, including a real estate company, a coffee house, an artists' gallery, a credit organization, and most recently, a 7-Eleven store. It now belongs to the Community Redevelopment Agency of the City of Orlando and is designated for demolishment in order to create more green space for Lake Eola Park. (Past image, photograph by Tim Orwick, courtesy of Orlando Memory.)

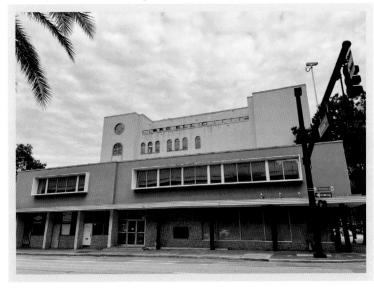

Brinson's Funeral Home was a Spanish-style building with an iron grill balcony and window awnings. Built on top of a former landfill in the Parramore district near a housing project, today, it is a green space named after Zellie L. Riley, a businessman who founded what is now the African-American Chamber of Commerce of Central Florida. The park features local artwork, picnic tables, and barbecue grills. (Past image, courtesy of Florida Memory, State Library and Archives of Florida, S226.)

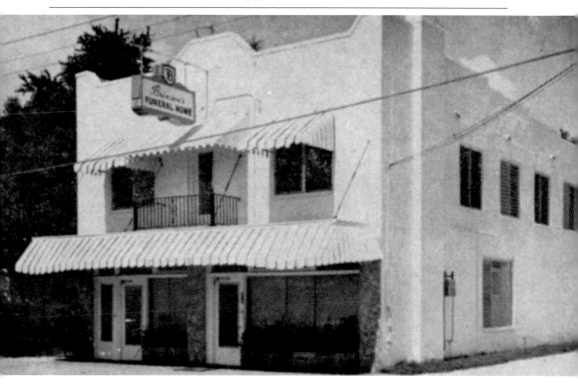

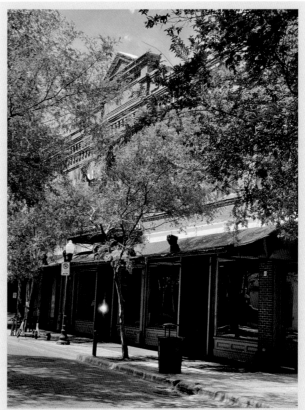

Elijah Hand, a Hoosier and an undertaker, bought this two-story brick building on West Pine Street in 1905. Formerly a hotel, the site sold coffins and cabinets, and had vehicles for hire. Hand was the first mortician in Orlando to embalm his clients, extending the interval between death and interment. His son Carey opened a funeral home across the street. The Elijah Hand building is rumored to be haunted; today, it is a bar. (Past image, courtesy of the Orange County Regional History Center, 1996-054-0437.)

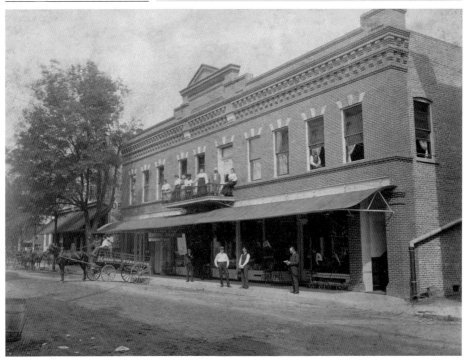

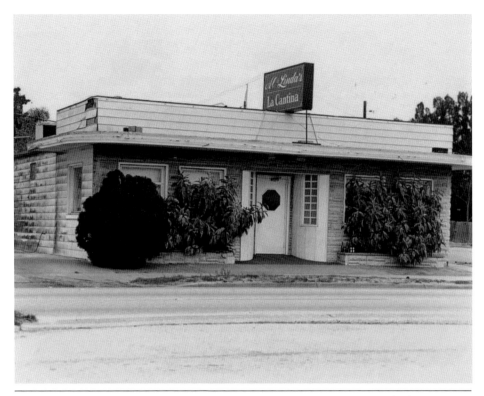

Once a cattle field, Linda's LaCantina Restaurant on East Colonial Drive is the oldest restaurant in Central Florida. Known as Al & Linda's LaCantina until the couple divorced, it was replaced with a larger building in 1979. A fire destroyed the restaurant in 1994, but the family-owned establishment reopened in 1995. The brick building remains a cultural icon for excellent steak in the center of the Sunshine State. (Past image, courtesy of Karen Hart.)

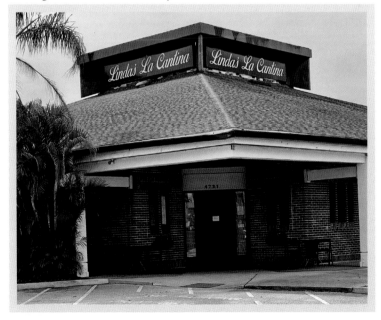

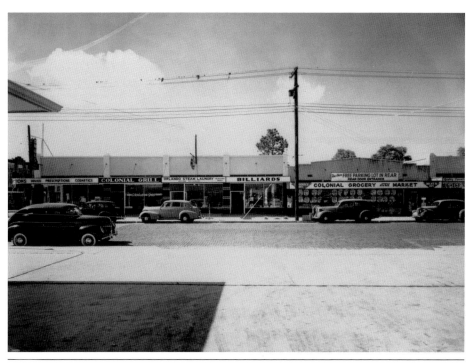

The area now known as the Mills 50 Mainstreet District was once just the intersection of Mills Avenue and Highway 50 in downtown Orlando, featuring American mom-and-pop stores and empty storefronts. In 1975, after the fall of South Vietnam, Vietnamese refugees opened businesses revitalizing the area. The strip of road, once known as Little Viet Nam, now includes Dutch, Indian, and Cuban business owners. (Past image, photograph by Ricardo Ramirez Buxeda, courtesy of the Orange County Regional History Center, 1995-100-0529A.)

Built in 1928, the two-story, wood-frame building on North Rosalind Avenue in the Lake Eola Heights district once housed 1960s-era rock'n'roll radio station WHOO AM, featuring disc jockey Billy Love. Today, WHOO's former home is owned by an investment company with law offices on the ground floor. (Past image, photograph by Tim Orwick, courtesy of Orlando Memory.)

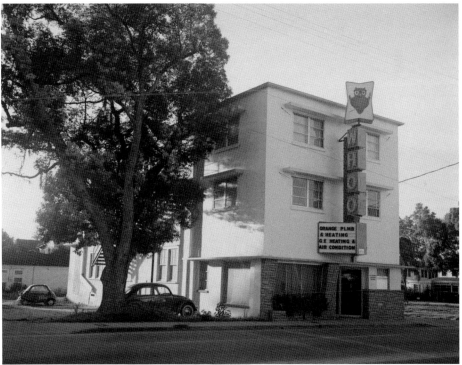

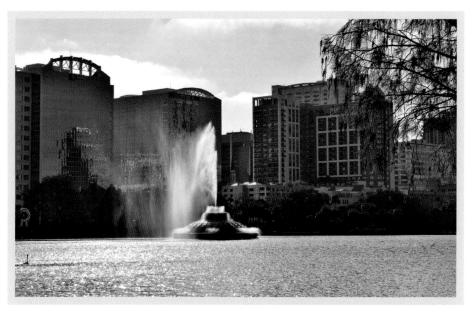

In 1925, this location was an A&P grocery store, and by the 1970s it was the CNA Tower on Orange Avenue. At 19 stories, it was Orlando's first skyscraper, with a private social club on the 18th floor. Today, the building is almost obscured in the skyline from Lake Eola Park. The former CNA Tower is visible behind the spire of the Downtown Baptist Church and now houses the Truist Bank. (Past image, courtesy of Special Collections & University Archives Department, University of Central Florida Libraries.)

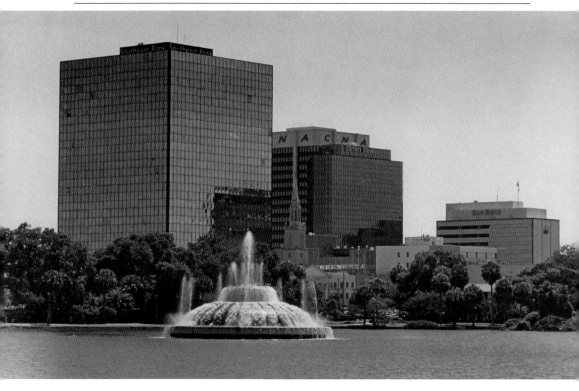

In 1963, the American Federal Savings and Loan on South Orange Avenue was known as the "round building" because of the horizontal concrete ring around the first two floors of the seven-story glass-sheathed structure. Torn down in 2015 to make room for the Front Yard fronting the Dr. Philips Center, the concrete framework of the bank is preserved at the Orange County Regional History Center. The lattice-like architectural feature helped cool buildings in hot climates. (Past image, courtesy of HuntonBrady Architects.)

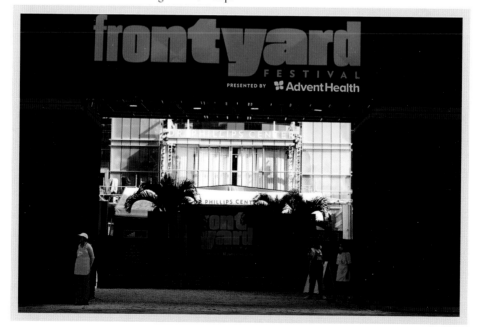

The State Bank of Orlando & Trust Company, a nine-story brick skyscraper downtown, was designed by architect William Stoddart in 1893. The bank was built in the Commercial style featuring Neoclassical elements such as starkness of form, muted colors, and distinct horizontals and verticals. Professional, educational, and government offices rented space in this building, which at one time offered a Christian Science reading room. (Past image, courtesy of Florida Memory, State Library and Archives of Florida, PR07966.)

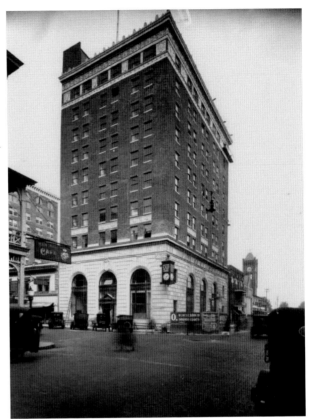

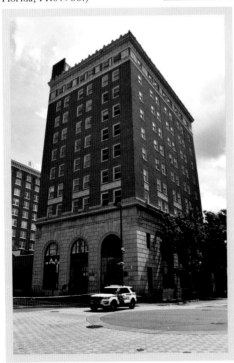

MUNICIPALITIES

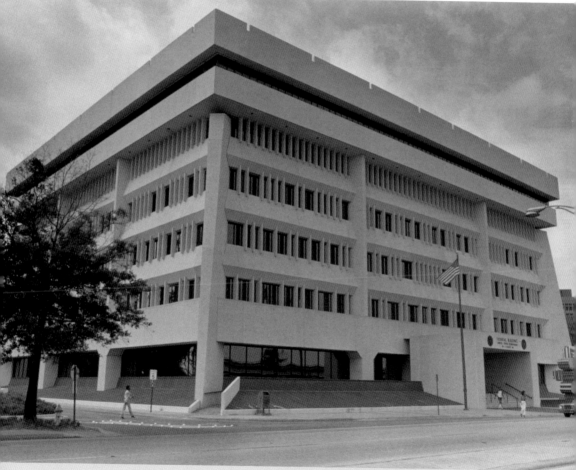

Named after Judge George C. Young, the federal building and courthouse on North Hughey Avenue were built in 1975 in the Contemporary architectural style. Yet, even at six stories and 82,000 square feet, it was soon inadequate to accommodate Orlando's burgeoning growth. An expansion to the federal courthouse was completed in 2007. Today, the original building is used mainly for bankruptcy cases. (Courtesy of Special Collections & University Archives Department, University of Central Florida Libraries.)

Serial killer Ted Bundy may have mounted these federal courthouse steps in 1987 for his hearing on a continuance of his death sentence. The George C. Young US Courthouse and Federal Building Annex incorporated some design restructuring in its 2007 expansion, including reversing the North Hughey Avenue entrance to the other side of the building. The newer entry interconnects architecturally with the old courthouse. (Past image, courtesy of Special Collections & University Archives Department, University of Central Florida Libraries.)

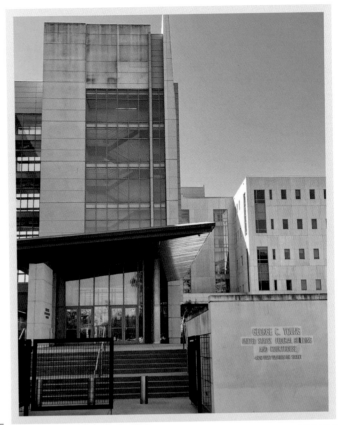

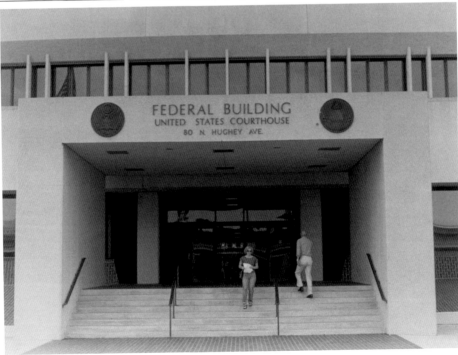

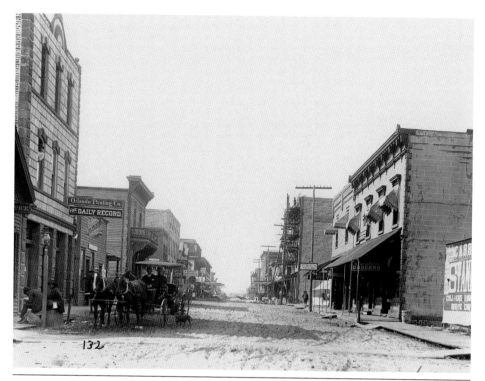

In 1882, on Pine Street in downtown Orlando, a horse-driven surrey navigates dirt paths. Men frame the sides of the road or lounge in front of the YMCA. Merchants compete side by side. The *Daily Record,* a precursor to the *Orlando Sentinel,* is on the left. Building debris is everywhere, because then, as now, the city was always developing and refurbishing. (Past image, photograph by Stanley J. Morrow, courtesy of Florida Memory, State Library and Archives of Florida, RC07547.)

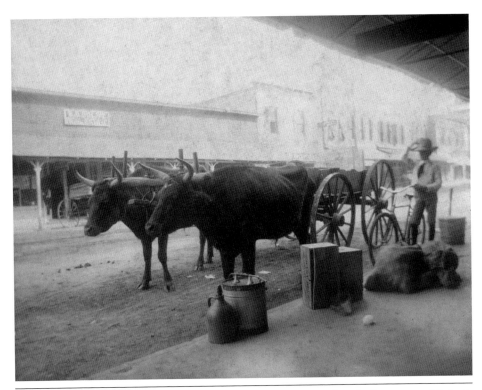

Nineteenth-century Orlando had muddy streets where razorback hogs rooted in the garbage off the dirt path that became Orange Avenue. Cows were herded from downtown every day, and yoked oxen transported farmers. One version of how Orlando was named involved a man named Orlando steering an ox cart, falling ill, dying, and being laid to rest near Lake Eola. Thus the local saying, "There lies Orlando." (Courtesy of the Orange County Regional History Center, 2009-001-0061.)

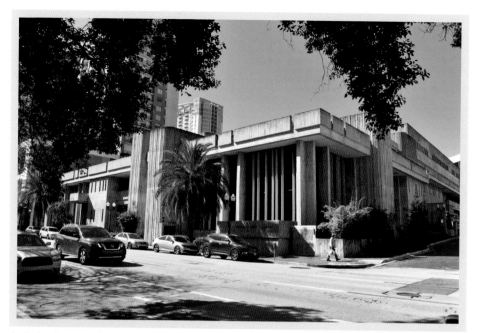

As the headquarters for the Orange County Library System, the Orlando Public Library has presided over Central and Rosalind Avenues since its beginning as Albertson Public Library in 1923. The Albertson Library was torn down, and the Orlando Public Library opened its doors in 1966. Architect John Johansen, a devotee of the Brutalism style, designed the poured concrete Modernist structure. The building was expanded and refurbished 20 years later. (Past image, courtesy of Florida Memory, State Library and Archives of Florida, N036362.)

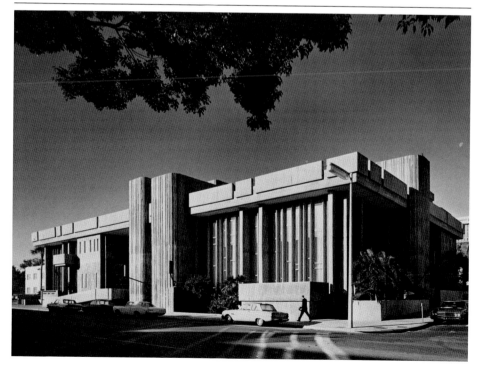

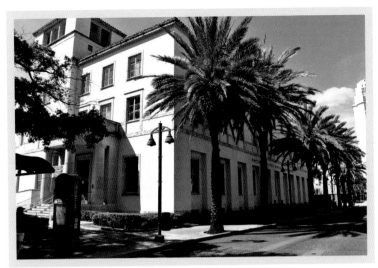

Purchased from the Catholic Church in 1939, the current downtown Orlando Post Office was designed by Louis Simon in the Northern Italian Palazzo Revival style. Proportioned with rows of corniced marble casement windows and a tower atop a tapered roof, the portico features columns topped with a balcony. The site, a historic Orlando landmark, is owned by the Catholic diocese and the federal government. (Past image, courtesy of Florida Memory, State Library and Archives of Florida, PR07997.)

Post Office, Orlando, Fla.—12

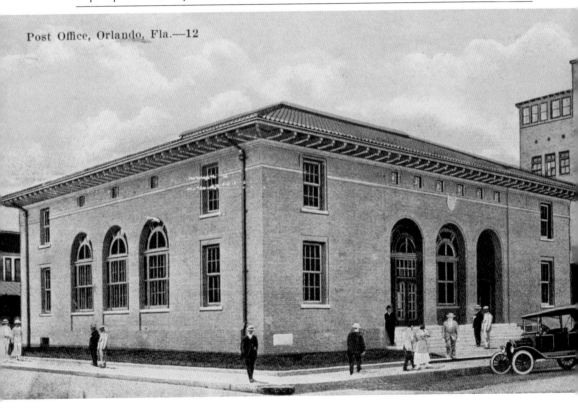

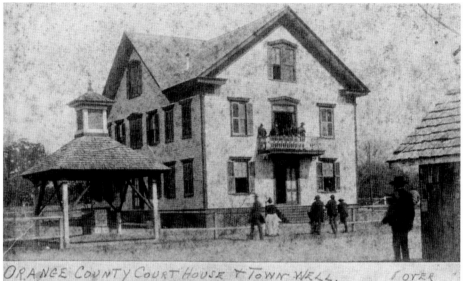

ORANGE COUNTY COURT HOUSE & TOWN WELL. FOYER

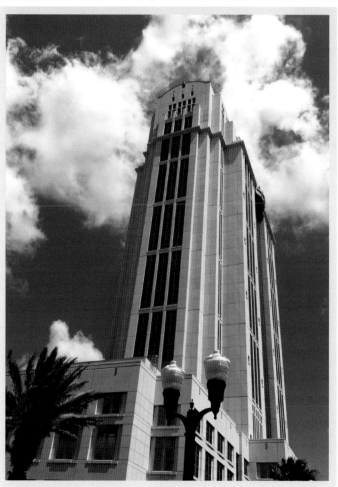

In 1874, the frame Orange County Courthouse typified Orlando's rural roots with its modest three stories, a community well, and watering trough for horses. It was moved in 1891 to the northeast corner of Church Street and Main (now Magnolia Avenue), where it was incorporated into the Tremont hotel. The present-day Orange County Courthouse, built in 1998, is on North Orange Avenue. At 23 stories, it is the third tallest building in Orlando. (Past image, courtesy of Florida Memory, State Library and Archives of Florida, RC04001.)

The 1894 Orange County Courthouse was an 80-foot red sandstone building with a clock tower, a bell, and a decorative colonnade. Eventually, the courthouse was torn down and its contents moved to the next-door limestone courthouse designed by Murray King in the Classical Revival style. Today, the original clock face of the tower is displayed in the courthouse, now the Orange County Regional History Center. The bell is housed on the ground floor of the present-day courthouse on North Orange Avenue. (Past image, courtesy of Florida Memory, State Library and Archives of Florida, RC03133.)

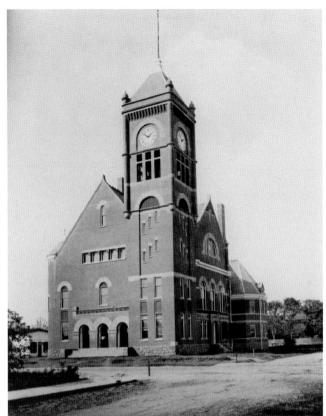

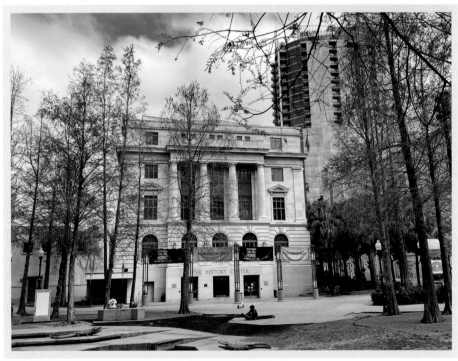

Years after the red courthouse was demolished, the courthouse annex replaced it. The annex was modern in structure with an abundance of bright colors, stainless steel, and glass fixtures on its eight floors. Unfortunately, asbestos was sprayed onto the steel framework, rendering the building uninhabitable by 1989. The site became Heritage Square, a green space with an alligator sculpture based on the famous Stanley J. Morrow photograph. (Past image, photograph by Hackett, courtesy of Florida Memory, State Library and Archives of Florida, DC040452.)

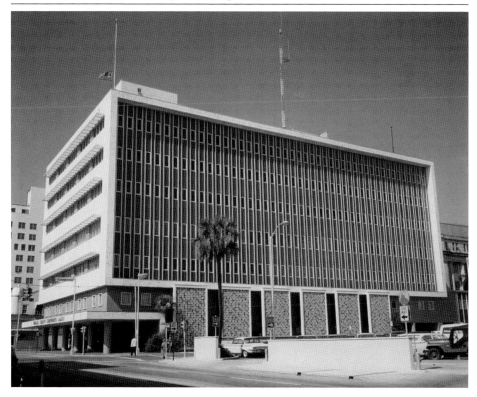

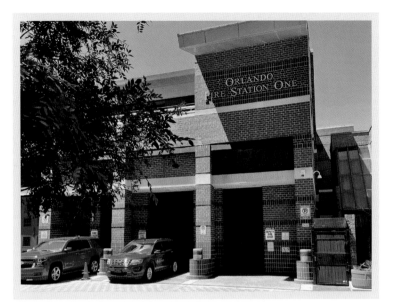

In 1884, a fire burned down blocks of businesses, leading to the formation of a fire brigade and the Oak Street Volunteer Fire Department in 1907. According to Dick Camnitz, historian with the Orlando Fire Museum, the first fire station on Oak Street, now Wall Street Plaza, used horse-drawn carriages. The present-day brick firehouse on West Central Boulevard occupies almost 40,000 square feet of downtown property and was built in 2009. (Past image, courtesy of Florida Memory, State Library and Archives of Florida, n036331.)

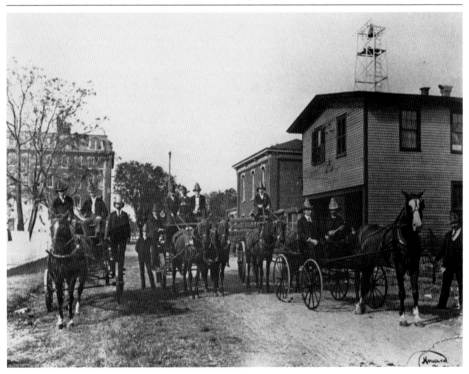

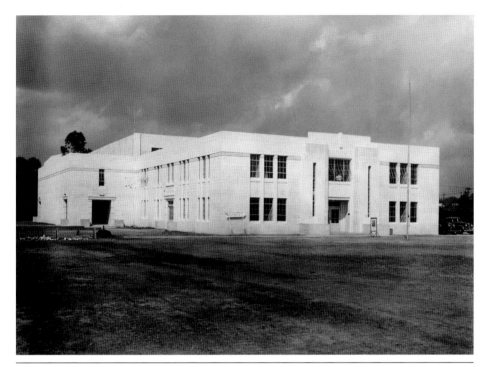

A Works Progress Administration project, the Davis Armory on West Livingston Street served as quarters and a gathering place for soldiers during World War II. Named for Lt. Colonel Davis, the first Orlando soldier killed in the war, the city rehabilitated the building in the 1960s as the Downtown Recreation Complex. The poured concrete, boldly colored Art Deco–style complex serves the Parramore community as well as the Orlando Magic, who use it as a practice gym. It is a designated historic city landmark. (Past image, courtesy of the Orange County Regional History Center, 1995-100-2570.)

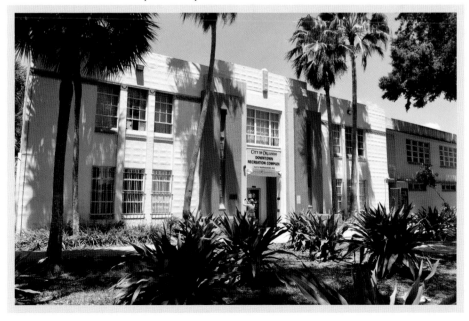

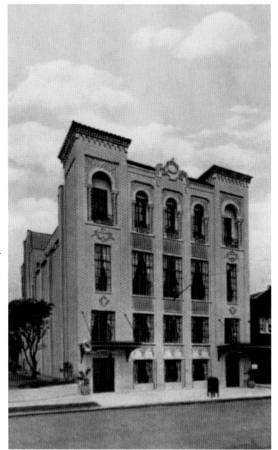

Located on East Central Boulevard, the original Orlando Chamber of Commerce was designed by Howard M. Reynolds in the 1920s. Forty years later, the chamber had a new location on Ivanhoe Boulevard, which lasted until 2016, when, following a merger of some city agencies, the chamber of commerce building was vacated. The former chamber building will house the Holocaust Museum for Hope & Humanity. (Past image, courtesy of Florida Memory, State Library and Archives of Florida, n036367.)

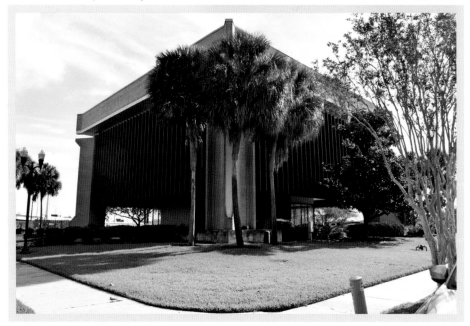

Originally the Orlando Light and Water Company, the Orlando Utilities Commission (OUC) constructed an Italian Palazzo Revival style plant in 1923 on North Orange Avenue using Lake Ivanhoe (pictured) as its reservoir. The two-story OUC power plant had two funnels, bays, and a flat-tiled roof to display a sign lit up for holidays. In the 1990s, the building was a center for performing arts. (Past image, courtesy of the Orange County Regional History Center, 2006-001-0172.)

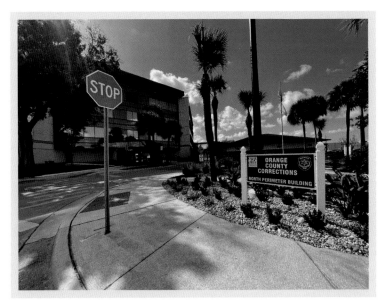

In 1884, the Orange County jail was on North Orange Avenue near where the Beacham Theater is today. Behind a fence, hangings could be seen from the second floor of the San Juan Hotel. The jail was torn down in 1925, and Baxton Beacham purchased the land for his theater. Today, the Thirty-Third Street Orange County Corrections Division is over 200,000 square feet and includes a maximum-security facility for up to 220 prisoners. (Past image, courtesy of the Orange County Regional History Center, 1992-021-0020.)

MUNICIPALITIES

RESIDENCES

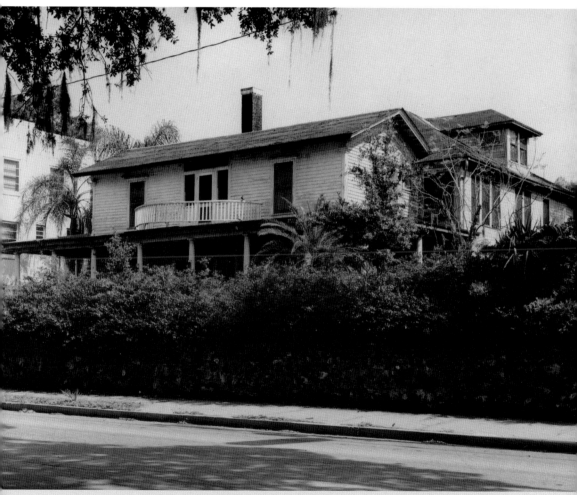

Jacob Summerlin's house once stood on the northeast corner of Rosalind Avenue and Central Boulevard. Summerlin is considered one of Orlando's founders. The house has been torn down. (Courtesy of the Orange County Regional History Center, 2018-001-0152.)

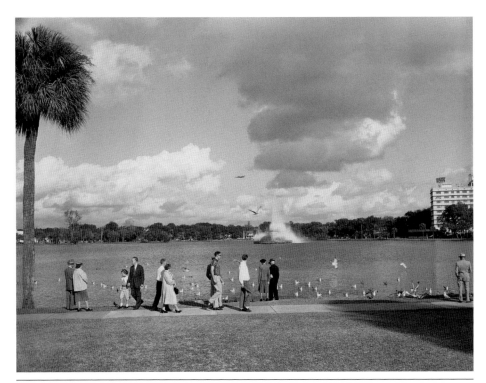

Cherry Hill Plaza opened in 1950 as a hotel-apartment building with 248 units. A relatively solitary figure on Lake Eola in those days, the Plaza featured nine stories of poured concrete and a view. It has been compared to the Beaux-Arts style of the New York Algonquin Hotel. Walt Disney announced the opening of Walt Disney World at a news conference at Cherry Hill Plaza in 1970. Today, it is a luxury apartment building. (Past image, photograph by Charles L. Barron, courtesy of Florida Memory, State Library and Archives of Florida, C026642.)

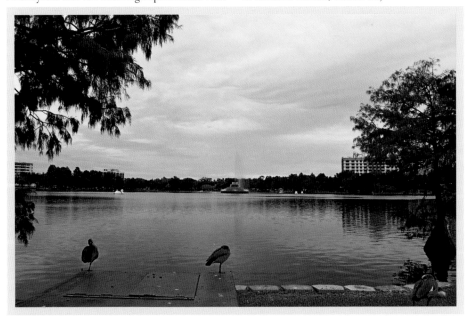

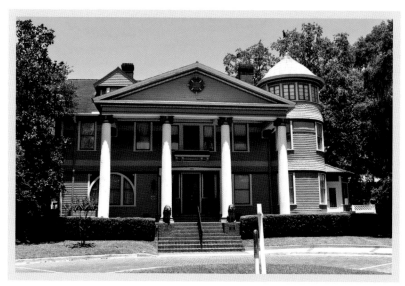

The Dr. Phillips house was built in the late 19th century and designed by L.M. Boykin. Purchased in 1912 by renowned philanthropist and citrus magnate Dr. Phillip Phillips, it was restored in the 1970s. With its wooden façades, it is the sole example of Shingle-style architecture in Orlando. Listed in the National Register of Historic Places, the building functions now as a wedding venue. (Past image, photograph by Robert Dittrich, Courtesy of the Orange County Regional History Center, 1990-136-0018.)

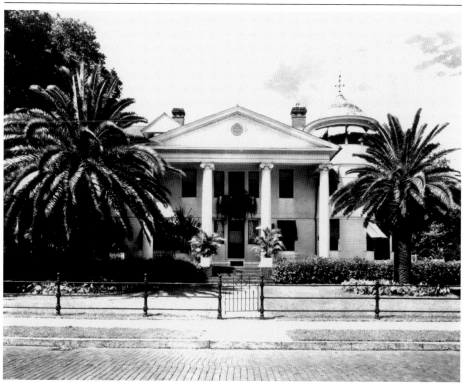

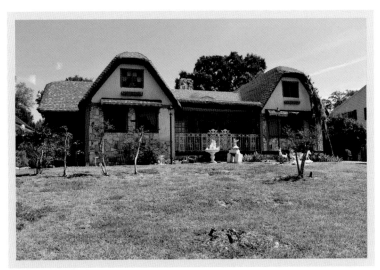

The Lake Adair property owned by Commissioner George B. Patterson in 1925 was styled as an English Cottage, including a thatched, inverted U-shaped roof. It had one wing for bedrooms and another for living quarters. The million-dollar "cottage" is privately owned, with 3,500 square feet of living space, a fireplace, gazebo, patio, and pool. A Ford Model T is rumored to be buried in the backyard. (Past image, courtesy of Denise and Steven Allen.)

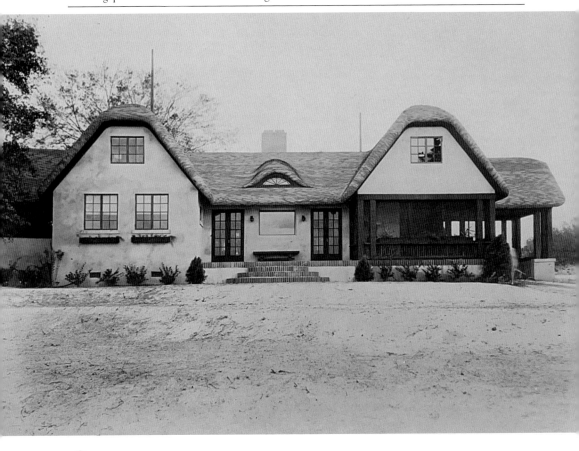

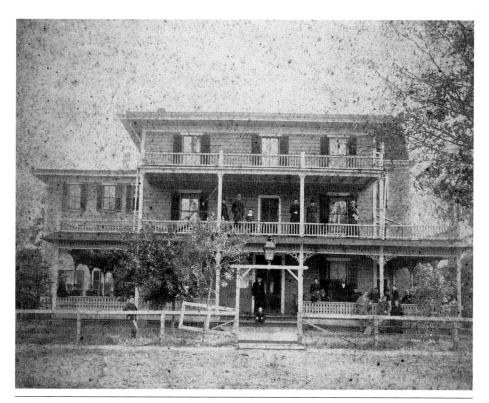

In College Park, across the street from Advent Health, this 1940s wood-frame bungalow is on the re-platted neighborhood grounds of a 19th-century Charles Joy mansion. A property owner at the advent of real estate around the turn of the 20th century, Charles Joy's name is still part of the subdivision today. The house is in a nationally registered historic district. (Past image, courtesy of Florida Memory, State Library and Archives of Florida, PR07993.)

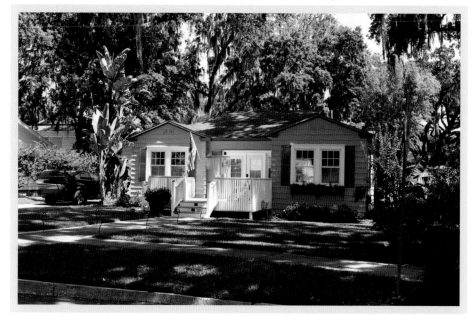

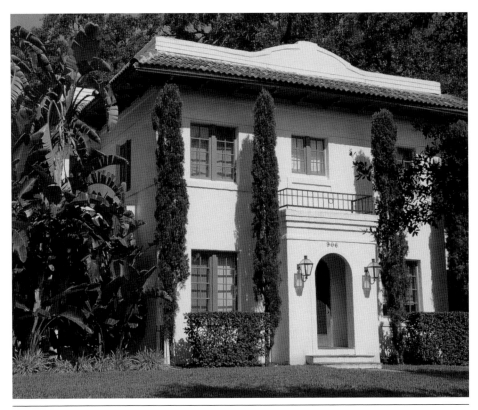

In 1930, this 3,500-square foot Mediterranean Revival poured concrete home was built in the Lake Adair/Lake Concord Historic District. Its red-tiled rooftop, white stucco peripherals, and overhanging eaves are examples of Orlando's eclectic architectural styles. (Past image, courtesy of Lake Adair–Lake Concord Historic District.)

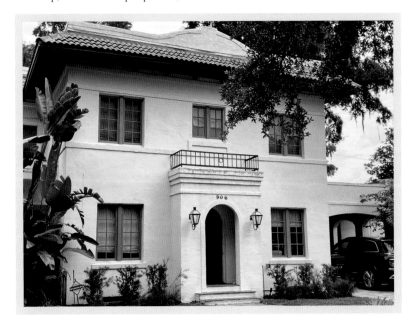

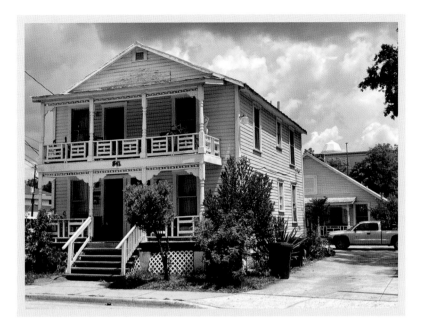

This 1920s Victorian house and cottage were saved from demolishment by their historic district designation. Originally owned by Woodford Maxey, a mail carrier, both structures incorporate identical decorative trim around the porches. The rear cottage style is Folk Victorian. Today, the house is owned by an investment firm and is leased as a duplex. It is an Orlando historic landmark. (Past image, courtesy of the City of Orlando's Downtown Orlando Historic District Walking Tour.)

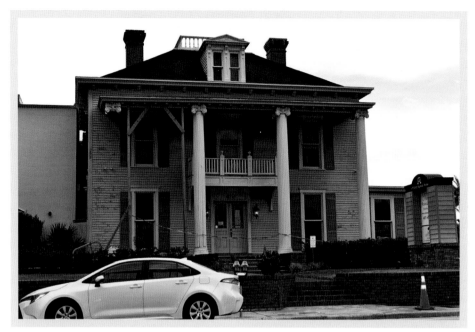

Known as Magnolia Manor, the 1880s Robinson house possessed a magnolia tree of such beauty that the name of the avenue it oversaw was changed from Main to Magnolia. The two-story New England Colonial Revival structure with columns, a gable, and a widow's walk is an important part of Orlando's history, as was its owner. Robinson Street is named after Samuel Robinson, an Orlando surveyor and civil engineer. (Past image, photograph by John Markham IV, courtesy of the Orange County Regional History Center, 1996-054-0024.)

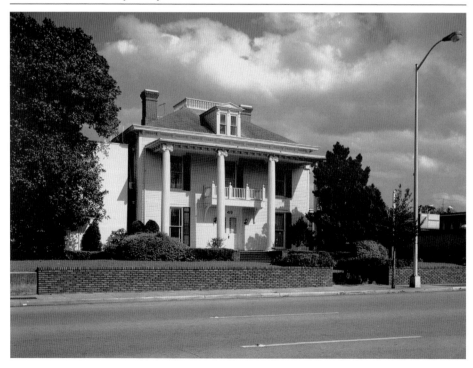

SCHOOLS

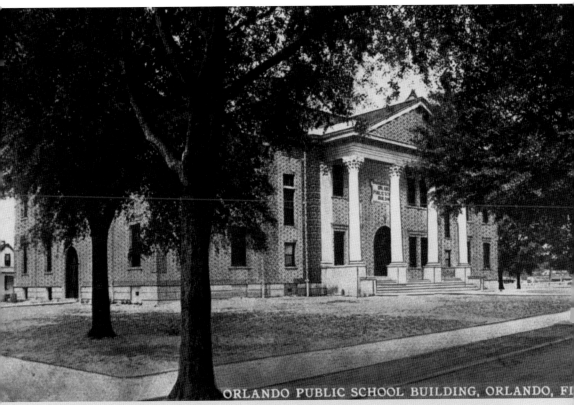

ORLANDO PUBLIC SCHOOL BUILDING, ORLANDO, FI

In 1926, the Orlando Public School Building on East Robinson Street was an impressive structure with six columns, a marble cornerstone, and transom windows. Actor Buddy Ebsen and astronaut John Young were alumni. The city outgrew the building by 1952 and renamed it after C.E. Howard, chairman of the board of trustees. Today, Howard Middle is a magnet school and an Orlando historic landmark with a waiting list of students. (Past image, courtesy of Florida Memory, State Library and Archives of Florida, n036373.)

Built in the 1930s with recycled bricks from the city's roads, Kaley School was a WPA project. Designed by Maurice Kressly, with its pitched roof and rows of brick arches sunken into the façade, it is the only public Tudor Revival structure in Orlando. Closed as a downtown public school in 2015, today it is an Orlando historic landmark and houses professional development services for Orange County Public Schools. Pictured in the past image is crossing guard Harold Worden. (Past image, courtesy of Sandra Worden Pickett.)

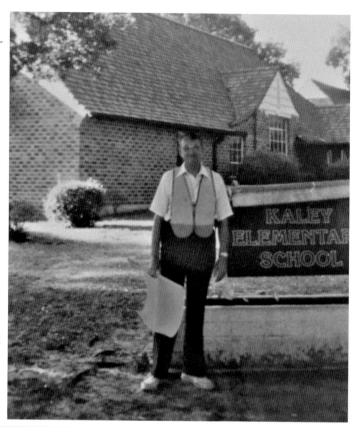

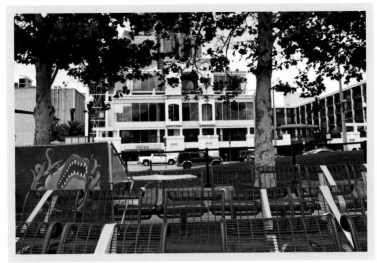

In 1922, Memorial High School was named to honor World War I Orange County veterans. With a view of Lake Eola, students attended the school until 1950. Constructed by J.C. Hanner in the Spanish Colonial Revival style, the building was briefly City Hall, then sold to a series of hoteliers, including the infamous Leona Helmsley's Harley Hotel. Today, the Metropolitan at Lake Eola Condominiums reflects Orlando's downtown emphasis on a consumer base. (Past image, courtesy of Florida Memory, State Library and Archives of Florida, PR295152.)

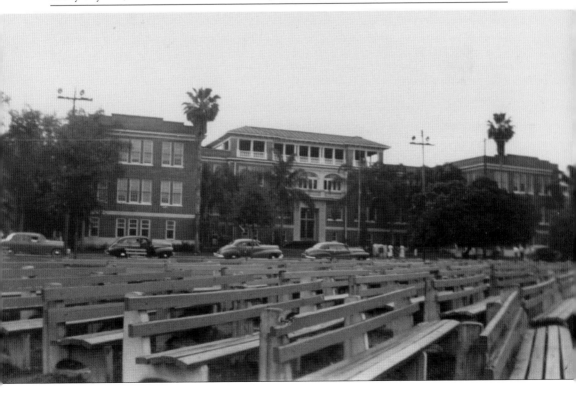

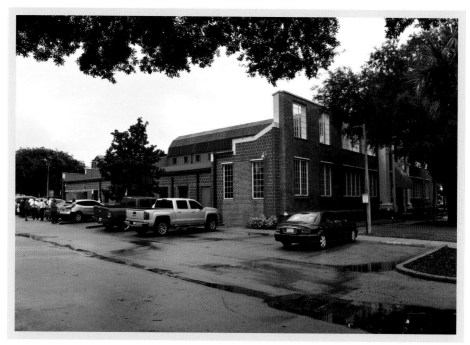

Designed by Howard Reynolds and named for Dr. J.B. Callahan, the first African American doctor to practice in Orlando in the 1920s, this brick Colonial Revival building became Callahan Elementary School when Jones High School relocated. Closed in the 1970s during Orlando's attempt at desegregation, it eventually became the Dr. J.B. Callahan Neighborhood Center, saving the neighborhood during a time when local development frequently disrupted long-standing African American communities. (Past image, courtesy of Florida Memory, State Library and Archives of Florida, S226.)

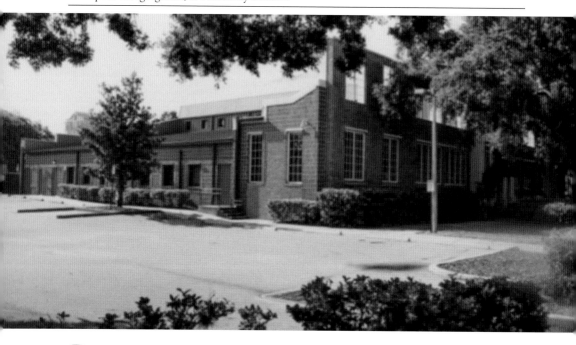

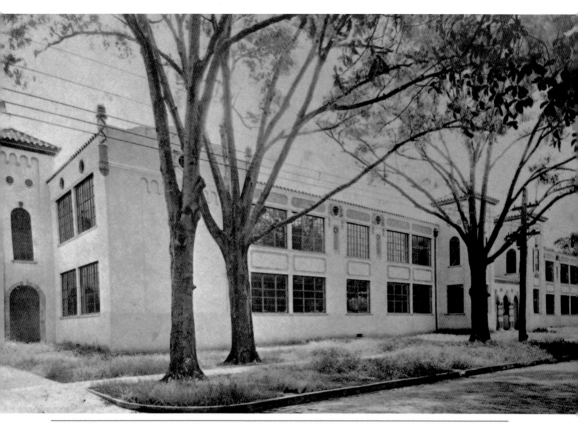

Built in 1926 by architect Howard M. Reynolds, the Mediterranean Revival–style Cherokee School is still part of the Orange County School System. Considered a Lake Cherokee Historic District architectural treasure, the arched entries and windows and the brightly colored terra-cotta embellishments merge Spanish and Moorish design elements. Sitting atop the columns for the last century are green terra-cotta owls, symbols of wisdom. (Past image, courtesy of Ron Jaffe.)

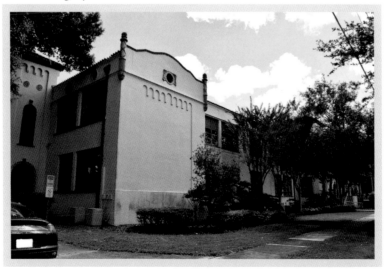

Formerly Johnson Academy, Jones High School began as a segregated school in a wooden church in the late 18th century. Named after principal L.C. Jones, it resided at today's Callahan Neighborhood Center until 1952, when it moved to South Rio Grande Avenue. Today, it is an international baccalaureate school with a renowned competitive marching band. The Jones High School Historical Society keeps a museum on site. (Past image, photograph by Dean Smith, courtesy of the Orange County Regional History Center, 1996-126-0071.)

Bibliography

"1918–1931." *Kehillah: A History of Jewish Life in Greater Orlando*. Orange County Regional History Center. orlandojewishhistory.com/1918-1931/.

"African-American History." Orlando Downtown Development Board. www.downtownorlando.com/Fun/African-American-History.

Antequino, Stephanie Gaub, and Tana Mosier Porter. *Lost Orlando*. Charleston, SC: Arcadia Publishing, 2012.

City of Orlando. "Historic Preservation." www.orlando.gov/Our-Government/Departments-Offices/Economic-Development/City-Planning/Historic-Preservation.

—————. "Z.L. Riley Park." www.orlando.gov/Parks-the-Environment/Directory/Z.L.-Riley-Park.

Clark, James C. *Orlando Florida: A Brief History*. Charleston, SC: The History Press, 2013.

Connolly, Patrick. "Orlando: 9 Best Views of the City Beautiful." *Orlando Sentinel*. March 3, 2021.

Dickinson, Joy. "A Century Ago, Mollie Ray Opened Doors to Orlando's Newest School." *Orlando Sentinel*. March 21, 2021.

—————. "Grateful for Arches, Eola Art and 50 Years of Hope." *Orlando Sentinel*. November 28, 2021.

—————. "Women Architects Shaped Early Orlando-Area Landmarks." *Orlando Sentinel*. April 24, 2022.

Fraser, Trevor. "100 Years Ago, Orlando's Biggest Housing Boom Roared with the 1920s." *Orlando Sentinel*. May 28, 2021.

—————. "New Venues Looking to Add Spark to North Orange Avenue Downtown. *Orlando Sentinel*. February 8, 2018.

Gillespie, Ryan. "Parramore Prepares to be Orlando's Next Main Street." *Orlando Sentinel*. February 18, 2022.

"Landmark Nomination Supplemental Sheet." www.orlando.gov/files/sharedassets/public/departments/edv/city-planning/landmark-review-supplement.pdf.

Marin, Michele. "Tour of Orlando's Colonial Architectural Landmarks." The Culture Trip. August 16, 2017. theculturetrip.com/north-america/usa/florida/articles/tour-of-orlandos-colonial-architectural-landmarks/.

Orlando City Directory. 1923, 1926.

Orlando Negro Chamber of Commerce. *The Voice of Orlando*. www.floridamemory.com/items/show/329107.

Rajtar, Steve. *A Guide to Historic Orlando*. Charleston, SC: The History Press, 2006.

Suris, Oscar. "McCrory's Must Exit Downtown." *Orlando Sentinel*. August 17, 1989. www.orlandosentinel.com/news/os-xpm-1989-08-17-8908172200-story.html.

Tarnasky, Daniel. *Galt*. Charleston, SC: Arcadia Publishing, 2019.

"Temple Israel." *Kehillah: A History of Jewish Life in Greater Orlando*. Orange County Regional History Center. orlandojewishhistory.com/temple-israel/.

"The Exclusive Rundown of Orlando's Best Black History Month Celebrations." Best Life Babe. bestlifebabe.com/index.php/2019/02/03/the-exclusive-rundown-of-orlandos-best-black-history-month-celebrations/.

Thompson, Geraldine Fortenberry. *Orlando Florida*. Charleston, SC: Arcadia Publishing, 2003.

Twardy, Chuck. "Downtown: an Architectural Tour." *Orlando Sentinel*. July 23, 1991. www.orlandosentinel.com/news/os-xpm-1991-07-23-9107210042-story.html.

DISCOVER THOUSANDS OF LOCAL HISTORY BOOKS
FEATURING MILLIONS OF VINTAGE IMAGES

Arcadia Publishing, the leading local history publisher in the United States, is committed to making history accessible and meaningful through publishing books that celebrate and preserve the heritage of America's people and places.

Find more books like this at
www.arcadiapublishing.com

Search for your hometown history, your old stomping grounds, and even your favorite sports team.

Consistent with our mission to preserve history on a local level, this book was printed in South Carolina on American-made paper and manufactured entirely in the United States. Products carrying the accredited Forest Stewardship Council (FSC) label are printed on 100 percent FSC-certified paper.

MADE IN THE